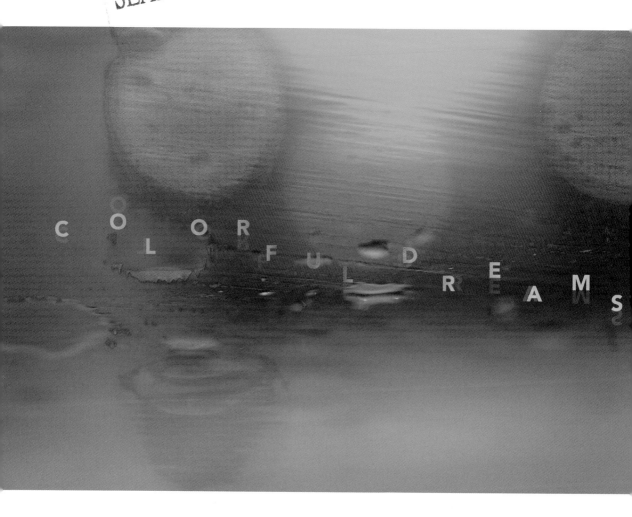

COLORFUL DREAMS

What do you think about when you're waiting for the bus?

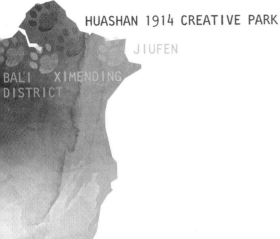

TAMSUI RIVER

The Tamsui River is one of Taiwan's three longest rivers. North of the river mouth is a town also called "Tamsui."

HUASHAN 1914 CREATIVE PARK

Originally a wine factory under Japanese rule, and since remodeled into a cultural events space.
In addition to frequent exhibitions and performances, there's also a fashionable gallery and restaurant.

JIUFEN

A renowned tourist spot in the north, Jiufen is an old mountain town facing the ocean, a maze of damp alleys and cobblestone slopes. Though Jiufen is rumored to be the model for the *Spirited Away* movie, Studio Ghibli has denied this.

BALI DISTRICT

This district is south of the Tamsui River, across from the town of Tamsui. At the ruined port, you can see the traces of the old dock. Now one of the selling points is a large riverside park.

XIMENDING

Reputedly a popular gathering spot for youth in Taipei, but if you compared it to Tokyo it's more like Asakusa, a district that's no longer the hot spot it used to be.

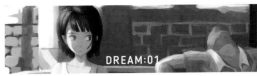

THE MAGIC AT 3:00 PM

Pg 4

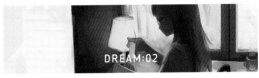

A CAFE

Pg 10

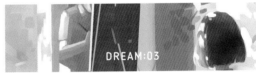

THE GUARDIAN ANGEL

Pg 16

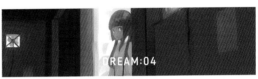

PHANTOM OF THE RUIN

Pg 22

THE END OF THE CITY

Pg 28

Xmas Eve

Pg 34

A RAINY DAY

Pg 40

THE ROLLING MARBLES

DREAM:08

Pg 46

ECHO ON THE BUS

DREAM:09

Pg 52

HIDE AND SEEK

DREAM:10

Pg 58

MEMORY OF A SQUARE

DREAM:11

Pg 64

PERSONAL STYLE

DREAM:12

Pg 70

SNOW IN SUMMER

DREAM:13

Pg 76

PHOTOGRAPHER OF LOVE

SPECIAL DREAM

Pg 82

TEMPLE SQUARE

A space suitable for festivals, ceremonies and events on the premises of a temple or mausoleum. There is no specific location name. It's comparable to the athletic grounds at a school. You can also set up street stalls and stands there.

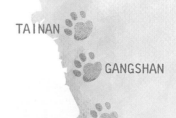

NEIWAN (HSINCHU)

TAIWAN

NEIWAN (HSINCHU)

Neiwan is the last stop on the Neiwan Line in the city of Hsinchu, an old town where the Hakka people originally settled in Taiwan. People say you can experience the unique culture of the Hakka people here, but nowadays it's really just an ordinary tourist spot.

TAINAN

Taiwan's oldest city. The government center from the first half of the 17th century under Dutch rule, until the end of the 19th century and the beginning of Japanese rule.

GANGSHAN

A suburb of Kaohsiung, and made an airbase under Japanese rule. It is still the site of an air force base.

TAINAN

GANGSHAN

LOVE RIVER/LOVE RIVERBANK
(KAOHSIUNG)

LOVE RIVER/LOVE RIVERBANK
(KAOHSIUNG)

The waterway most representative of Kaohsiung city, used for wood transportation when Taiwan was under Japanese rule. It became heavily polluted in the '60s as job-seekers gathered in Kaohsiung during its manufacturing boom, and was long known as the "Dirty River," but extensive maintenance and cleaning from the '80s has made it into a splendid sight-seeing spot today.

THE MAGIC AT 3:00 PM

"If you were in the countryside and needed to take a bus to the city,
you'd have to wait a long time..."

"If you were waiting on a summer afternoon, you would also be drenched in sweat..."

"Then, if you chose to take a closer look at a stretch of tree shadows
you hadn't noticed before..."

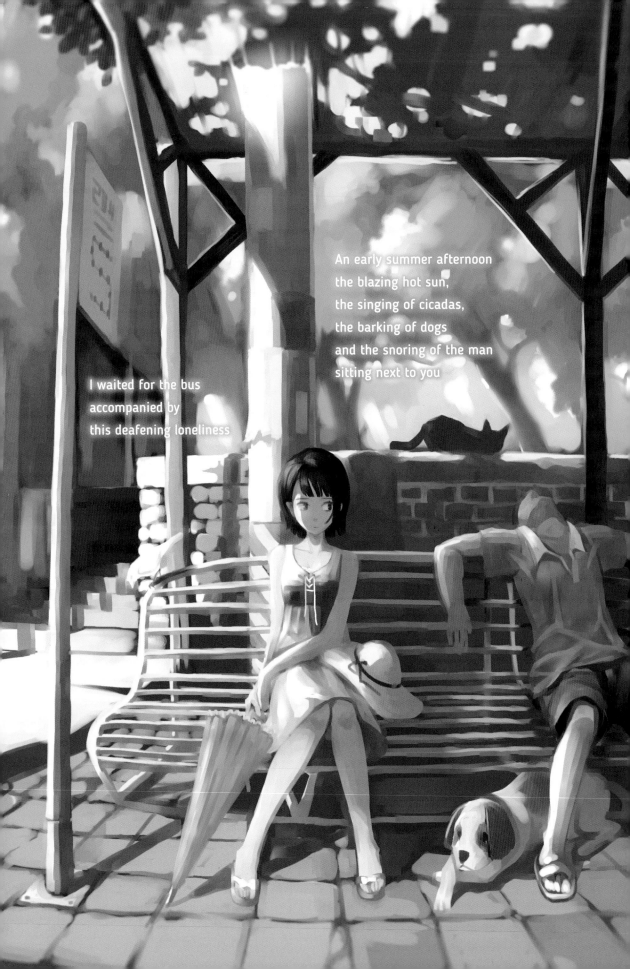

An early summer afternoon
the blazing hot sun,
the singing of cicadas,
the barking of dogs
and the snoring of the man
sitting next to you

I waited for the bus
accompanied by
this deafening loneliness

Flying fish leap from the pond

3:00 PM on the dot
the first magical sunlit rays
dappled the tips of my hair

In that moment
everything started to change

Look, the heat's too much poor howling dog
he melts into a puddle
finally, relief

Puffs out a cloud

The snoring man wears a black suit

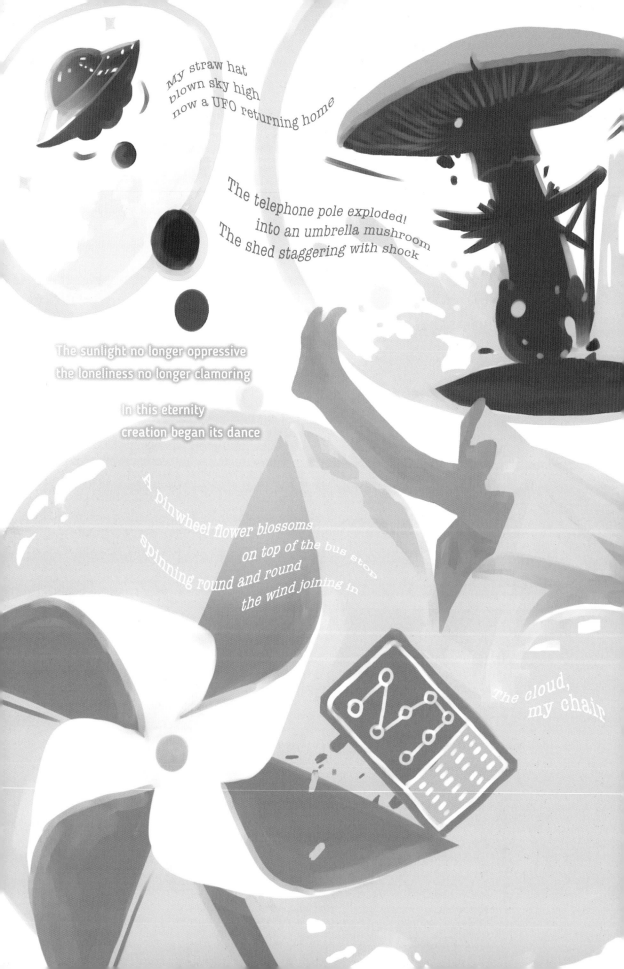

My straw hat
blown sky high
now a UFO returning home

The telephone pole exploded!
into an umbrella mushroom
The shed staggering with shock

The sunlight no longer oppressive
the loneliness no longer clamoring

In this eternity
creation began its dance

A pinwheel flower blossoms
on top of the bus stop
spinning round and round
the wind joining in

The cloud,
my chair

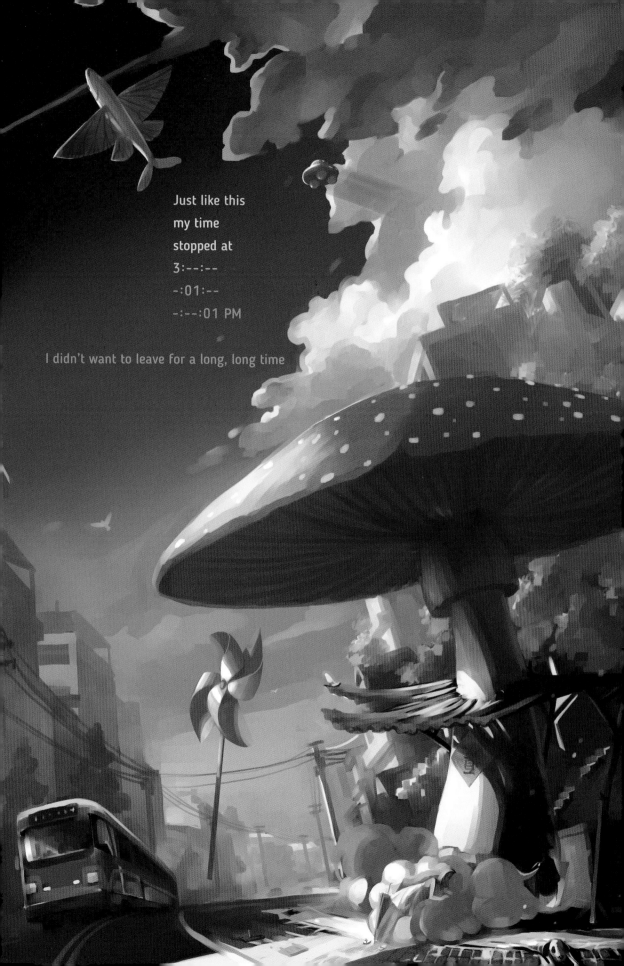

Just like this
my time
stopped at
3:--:--
-:01:--
-:--:01 PM

I didn't want to leave for a long, long time

"THE MAGIC AT 3:00 PM"

Waiting for the bus is so annoying. But if you live in Taipei, where the buses come often and have routes all over the city, you might not understand.

When I was young, if I wanted to take a bus from Tainan to Gangshan, the waiting time alone would be half an hour or even an hour. On top of that, back then the buses were all crude, smelly and shaky. It was a nightmare. I hated taking buses until I entered university.

Later on, I realized that both taking the bus and waiting for one can be interesting experiences. Particularly in the countryside or in the suburbs, if you're always wandering through the tourist sites or hustling to the next sightseeing destination, there is never time to take a break—there are always too many attractions to keep you busy. Everything is just flashing by. Only when you're about to leave, in the half an hour when you're waiting for the bus, can your thoughts finally calm down. Perhaps only then can you actually breathe in and smell where you are.

Then, you can begin to imagine the stories that belong here.

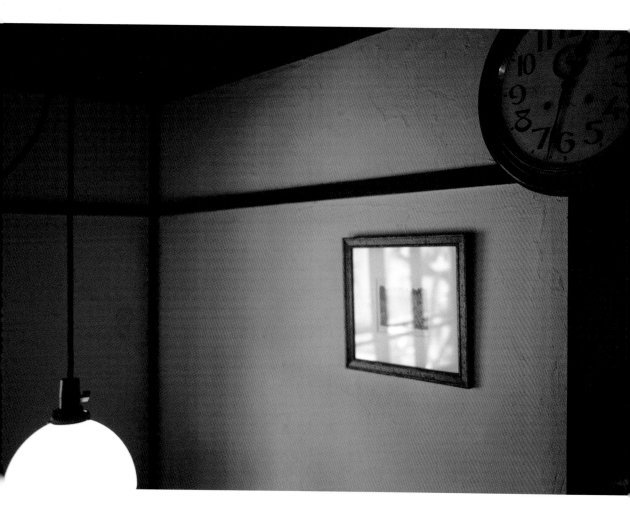

A CAFE

Because of the movie *A City of Sadness*, Jiufen has become a tourist spot with a lot of nostalgia.

But I didn't open a coffee shop here because it was trendy.

Opening up a shop is one thing, keeping it going is quite another.

"I like it here for the damp feeling in the air after rain, and the peaceful, empty streets."

"And of course I haven't forgotten the loyal customers..."

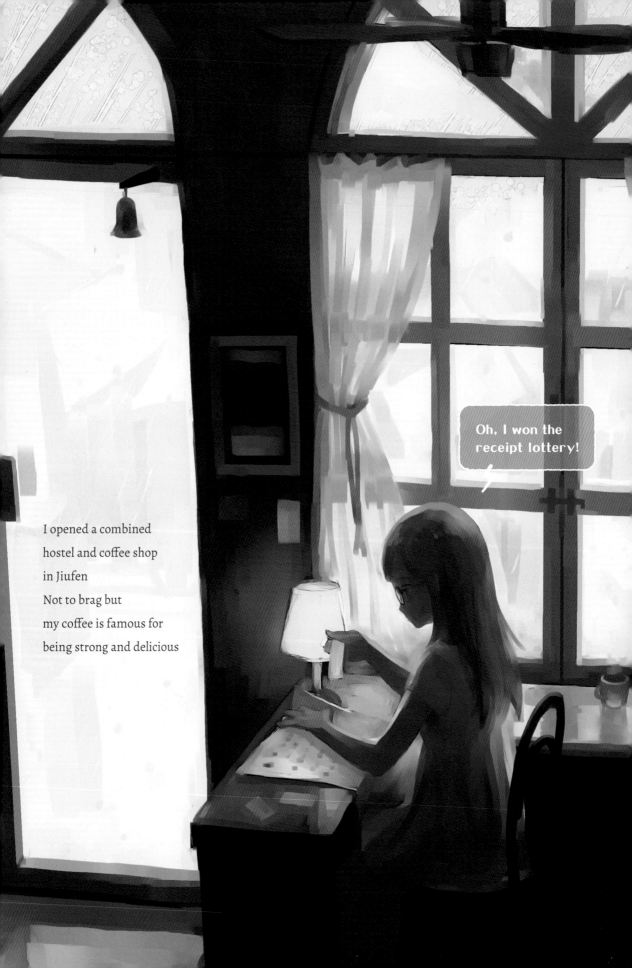

The shop is in an alley tourists rarely come by
There haven't been many customers this last half year
Some even say it's because the vibe is too creepy!

Ah...
They've come again!

I feel like these days
very few people simply want a nice cup of coffee

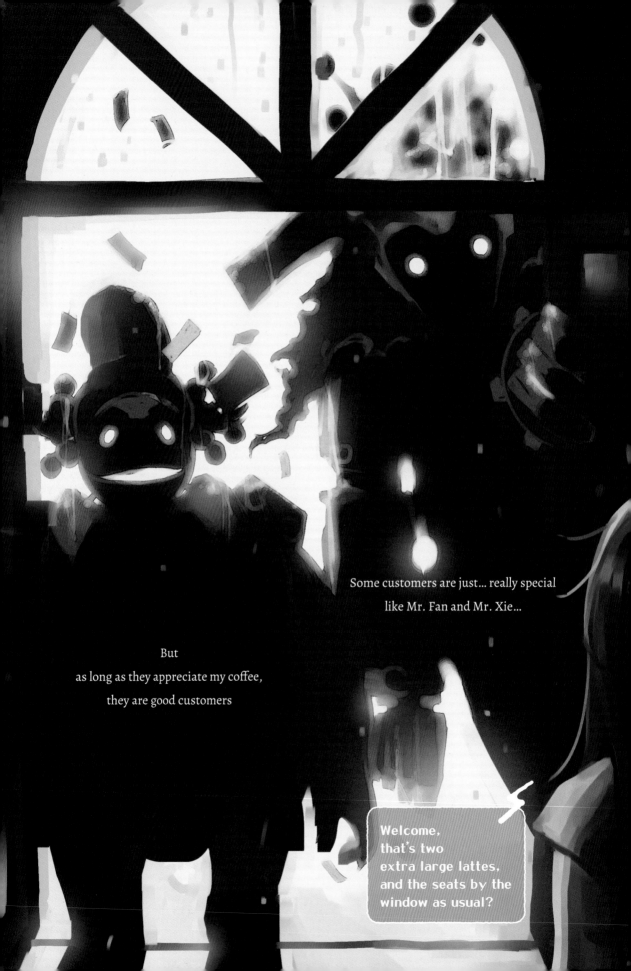

Some customers are just... really special
like Mr. Fan and Mr. Xie...

But
as long as they appreciate my coffee,
they are good customers

Welcome,
that's two
extra large lattes,
and the seats by the
window as usual?

Of course

don't expect them to pay on site

Oh! I won again!

"A CAFE"

I've read a few Japanese kaidan manga. They're not horror or gore. The stories integrate monsters and spirits into daily life. They have a slice-of-life feel and are very pleasant, not scary at all.

These stories are very interesting. Who says there has to be blood and guts whenever monsters are in the picture?

Jiufen is a bustling tourist spot, full of crowds and noise. But very few people venture off the main streets, making it feel like a ghost town sometimes. If I turn off the lively Jishan Street down an unobtrusive alley and walk a few steps, all there will be are a few faint yellow halogen lamps, my indistinct shadow cast before me, and the sound of people incredibly distant. It's as though I've stepped a generation backward.

I've passed by some hidden coffee shops, looked at their locked doors and wondered: Are there really ever any customers?

Then this story popped into my head.

DREAM:03
THE GUARDIAN ANGEL

"Have you been to Tamsui River or Neiwan? There're a lot of street artists who draw portraits around there."

"Now even a small town like ours has a street artist like that. I hear he's pretty cute…"

"I heard it's a college student studying art. That's nothing special…"

A while back, street portraits became really popular in our class
Apparently, in some alleyway
a cute guy who looks like a college student
will paint you and the "guardian angel" following you.

I, who won the watercolor competition at my school,
have seen a few of his paintings; his technique isn't bad
But I don't believe in all that superstitious nonsense!

I skipped make-up classes to sneak out and find this artist
to get him to draw my portrait
I was pretty curious about what the painting would show.

Side note: He's not that cute!
I guess at an all-girls school, any guy you see
could be considered cute...

It's done.
Come take a look!

What the heck!

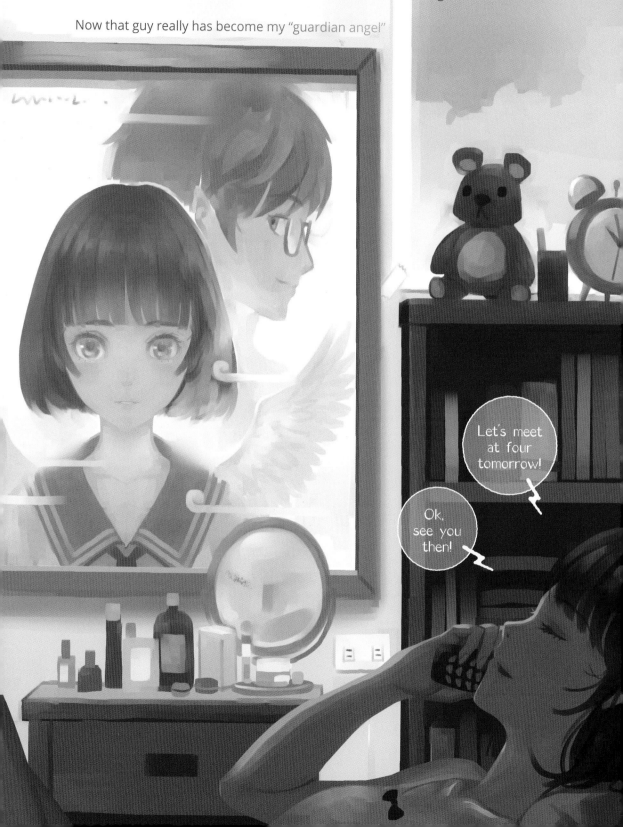

"THE GUARDIAN ANGEL"

Whether it's the Tamsui riverbank, Taipei Metro Mall, the Love Riverbank in Kaohsiung, or Neiwan in Hsinchu, you will always find street artists hard at work drawing portraits. There's usually a crowd around them. It seems like even people who aren't studying art still like to watch an artist at work.

There are usually three styles for these street-side portraits. One is total realism, which no longer seems very popular. There is also a cartoon style like the ones used in political satire, and finally a dreamy style commonly found on the covers of romance novels. Sometimes I wish I could find art of a different style or subject matter, but considering the general public's tastes, there's only so much you can do.

But what if someone could draw your guardian angel? That would be really interesting and fantastical, like knowing someone who can see ghosts. "Guardian angel" can also have non-mystical meanings, like for a boyfriend or a father.

So next time you see a street portraitist, don't just walk by and ignore them. Maybe their art is really different. If so, let me know.

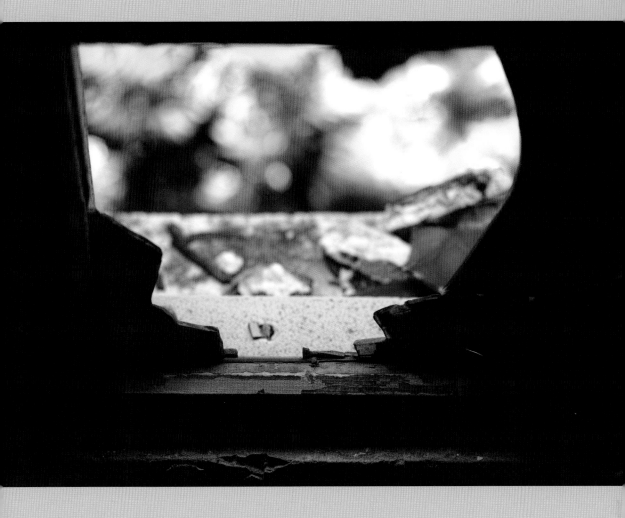

DREAM:04

PHANTOM OF THE RUIN

"If you've seen Shinichirou Kobayashi's ruins photography, you'll want to come explore this place with me."

Push open the half-closed door. The cobweb that greets you reminds you this place has long been forgotten.
Sit on the decrepit couch and watch a ray of light travel
from the clock on the wall to the playing cards in the corner, then the water bottle on the table.

"The sunlight of today touching the time of the past."

Quietly.

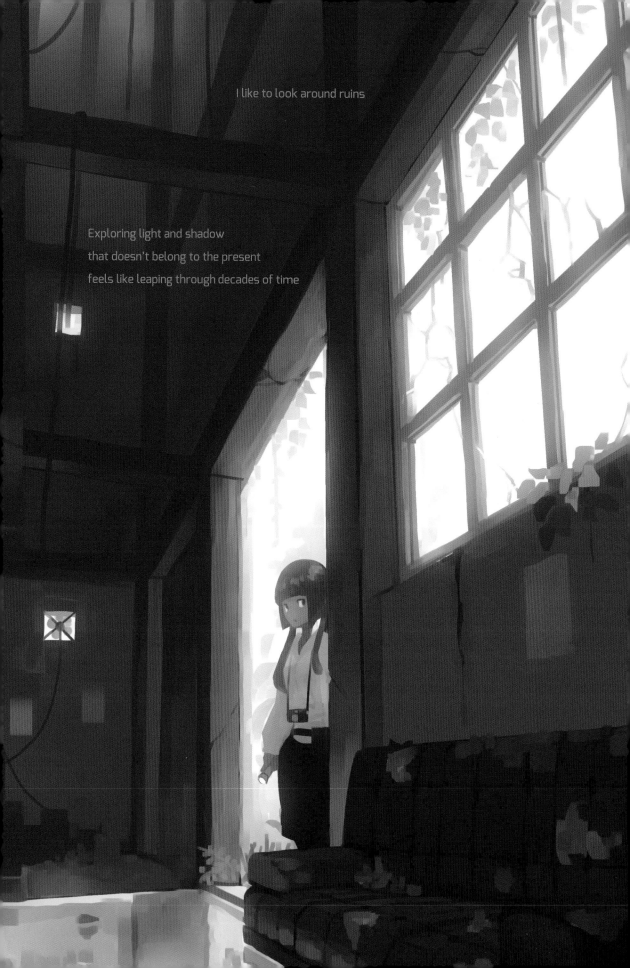

I like to look around ruins

Exploring light and shadow
that doesn't belong to the present
feels like leaping through decades of time

Occasionally, the people who were here
might have left a surprise

Pop in some batteries and it can still make noise!
Even though it's just a kind of rustling sound
I'll think of it as
a super-authentic nostalgic lullaby from the 1970s

Then, I'll take a good nap...

Sha~
Sha~
Sha~

Today is July 28, 1981, next up is
the weather report...

Sha~
Sha~
Sha~

ALL ABOUT

"PHANTOM OF THE RUIN"

I'm not sure when "ruins" started to become so trendy in Taiwan.

Some ruins even became popular destinations for photography, such as
the Huashan 1914 Creative Park. Ironically, sometimes photography
groups even got in each other's way because too many of them were
taking pictures at the same time.

I like to venture into ruins alone. I can't remember when I started really
getting into it. From what I recall, the first time I went to Japan, a friend
I was traveling with bought Shinichirou Kobayashi's collection
Haikyo Hyoryu (Drifting in the Ruins). The photos, with their dazzling
colors, seemed to have broken away from reality. It was as if the ruins
were still alive. They were thoroughly mesmerizing.

From a personal perspective, I saw time stop in those ruins. Traces of life
were frozen in that moment without any pretension. Calm within chaos.
A mummy telling its story.

Time flows differently in these ruins, which is what makes them so
attractive.

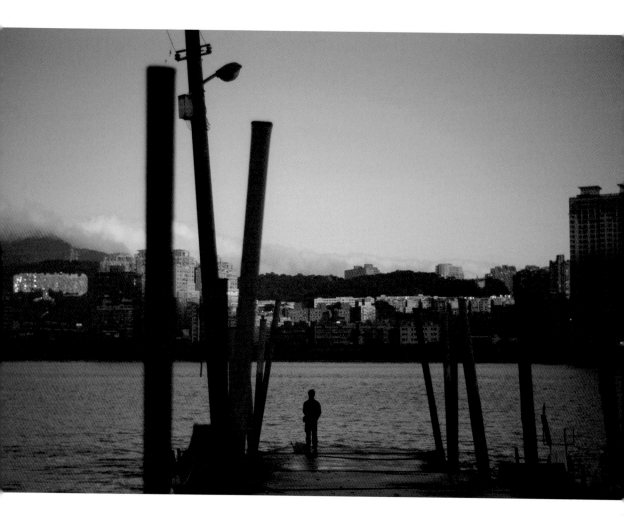

THE END OF THE CITY

"When I see a row of telephone poles, I wonder where they will end."

"Maybe at a large grassland with windmills."

"What about the end of love?"

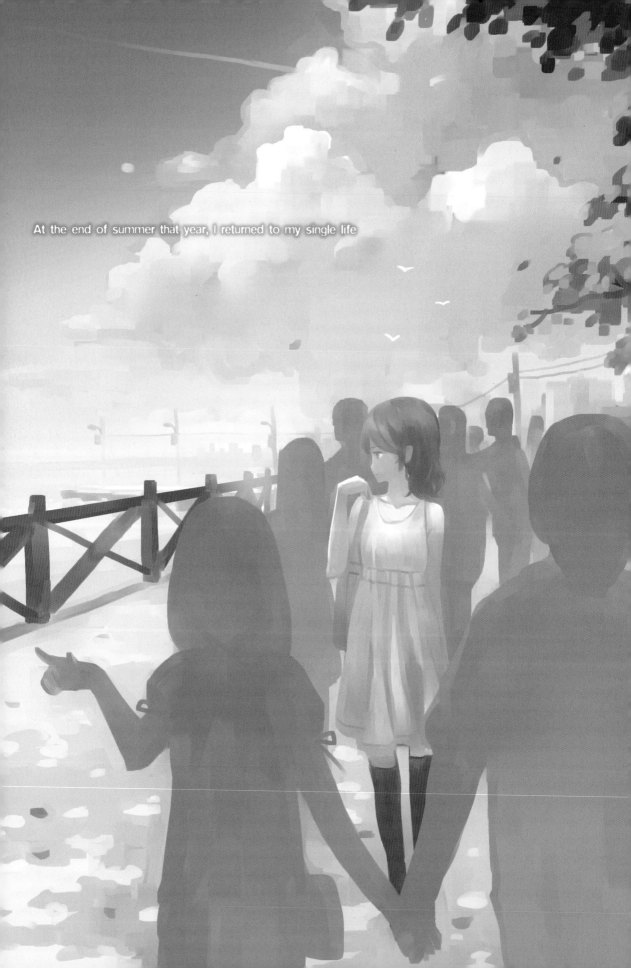

At the end of summer that year, I returned to my single life

I came back to
where we held hands for the first time
The left bank of Bali District is
still buzzing with activity
There was a time
when in the middle of all this hubbub
my world only consisted
of two people

Now
I'd rather fly to the end of the city
all by myself

I fell asleep at the entrance to the ferry
Only when I saw the moonlight through my tears

did I know it was midnight

Then I saw

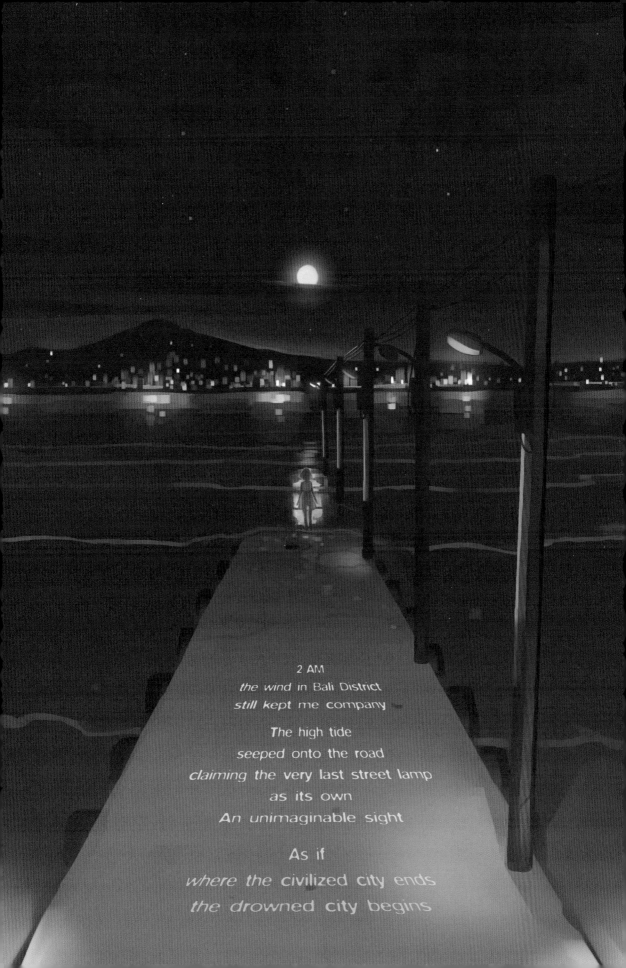

2 AM
the wind in Bali District
still kept me company

The high tide
seeped onto the road
claiming the very last street lamp
as its own
An unimaginable sight

As if
where the civilized city ends
the drowned city begins

ALL ABOUT

"THE END OF THE CITY"

There are many docks along the bank of the Tamsui River in Taipei's Bali District where people can moor boats. They consist of sloped concrete bridges lined with street lamps.

On the midnight of a full moon, you'll see the lower part of these lamps submerged by the high tide, which will float over the tip of the bridge.

From afar, it looks like the lamps are slowly being devoured by water, and the road ends in the sea.

Is this the end of a city in the real world, or the entrance to an underwater city?

I saw this on a drizzly night and it really moved me, but I can't capture even a tenth of the beauty of that moment here. If you have a chance, you must go see it for yourself.

DREAM:06
Xmas Eve

"When did Christmas Eve become a holiday for couples?!"
"The worst thing is, in this freezing weather
I still have to stand outside the restaurant and greet customers..."

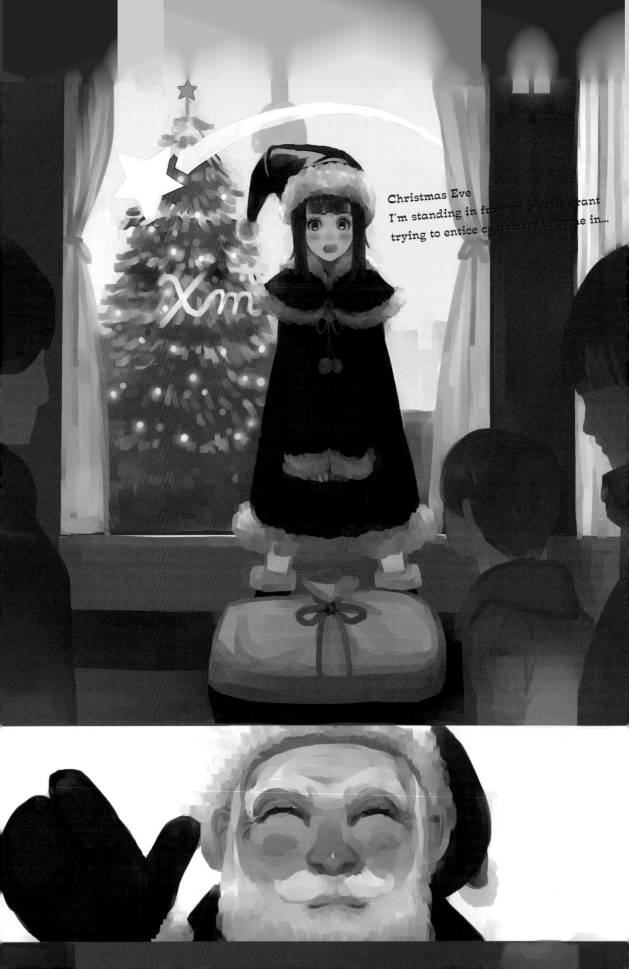

Christmas Eve
I'm standing in front of a restaurant
trying to entice customers to come in...

The restaurant across the street
also hired someone to dress like
Santa Claus

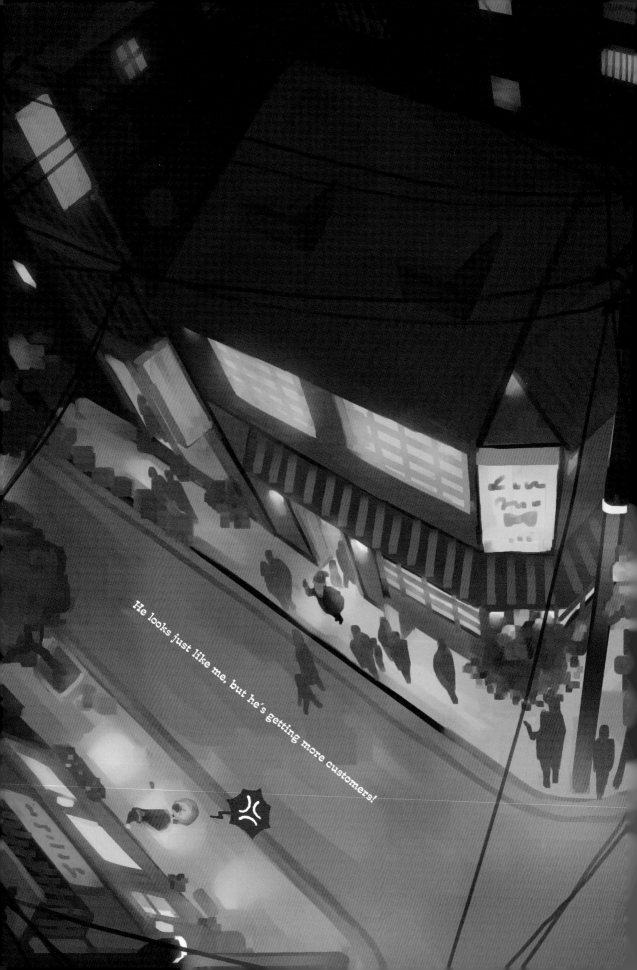

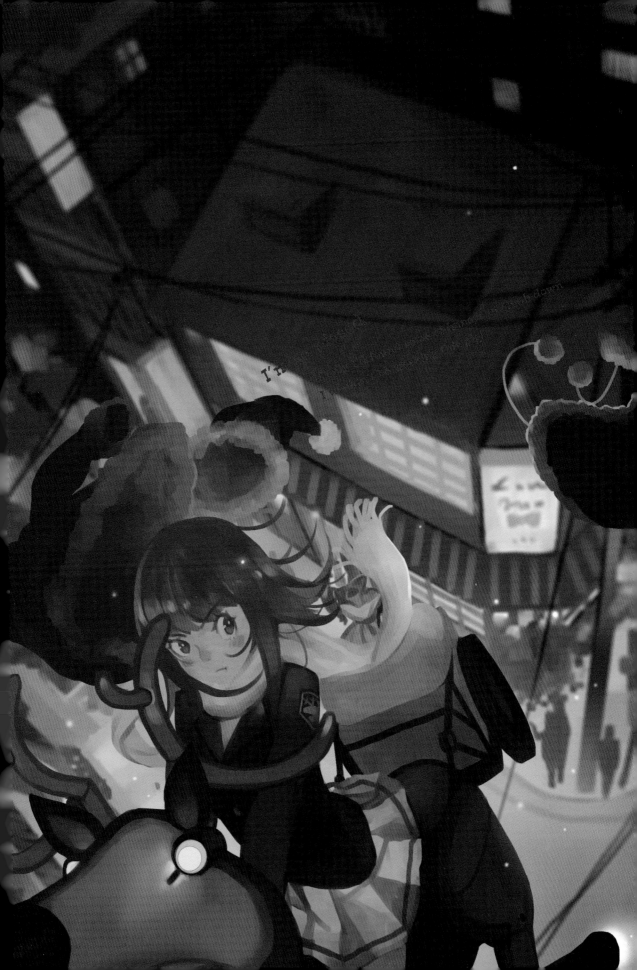

"Xmas Eve"

One Christmas Eve, I was trying to find a restaurant to eat at but couldn't get into a single one in all of Ximending.

The Western-style restaurants were all full.
The line at McDonald's was as bad as at a concert.

After searching for a long, long time, I finally found a mediocre-looking restaurant. After browsing the menu, I was super excited to order some stuff I didn't usually get to eat. Then the waiter, who took forever to get to me, calmly explained:

"You can't order anything on that menu today. Please take a look at this other menu, which has all the Christmas specials we're offering."

The new menu only had a single set meal, which cost three times the usual.

If my story had had a cute girl dressed like Santa greeting me at the door of the restaurant, maybe I would have reconsidered sitting down and ordering...

DREAM:07
A RAINY DAY

Distant rainclouds ganged up to protest the sun's unfairness.
From the eaves, raindrops conveyed their resentment, plip-plop, plip-plop.

"I've got to deliver a bento in this weather... oy."
The rain got worse.

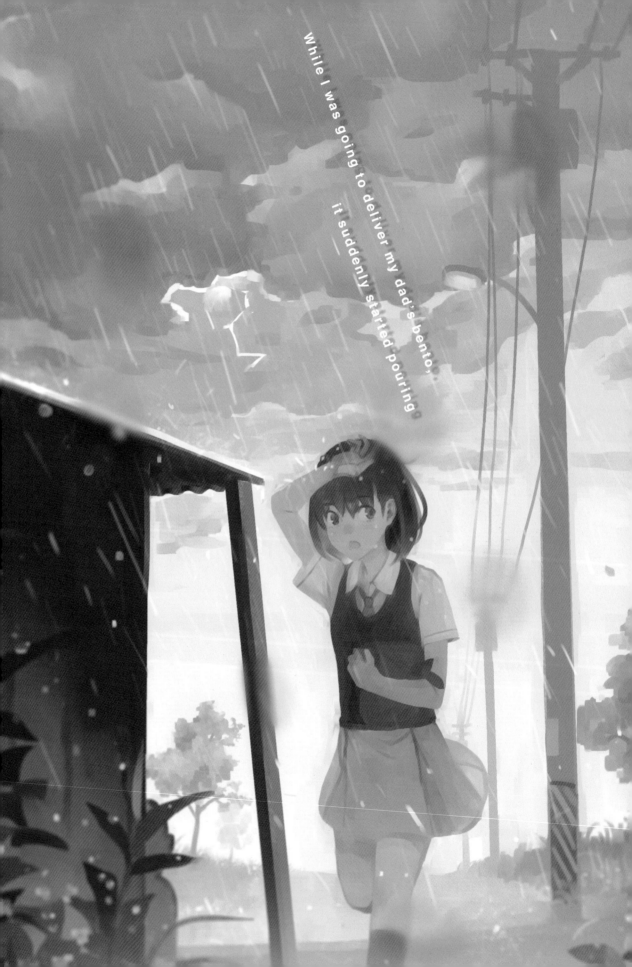

I hid in a tiny temple...

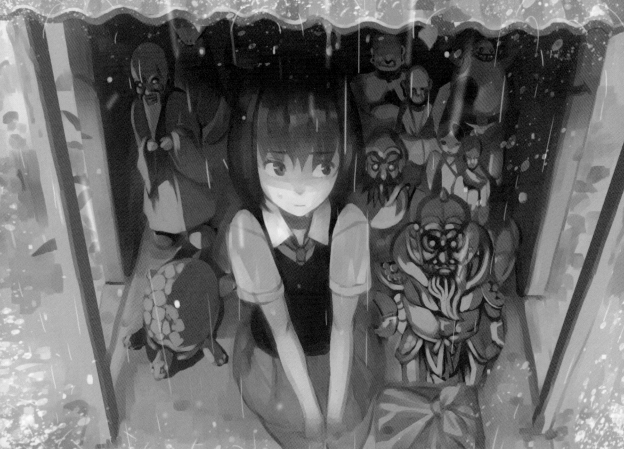

The shed was filled with
abandoned statues of various gods

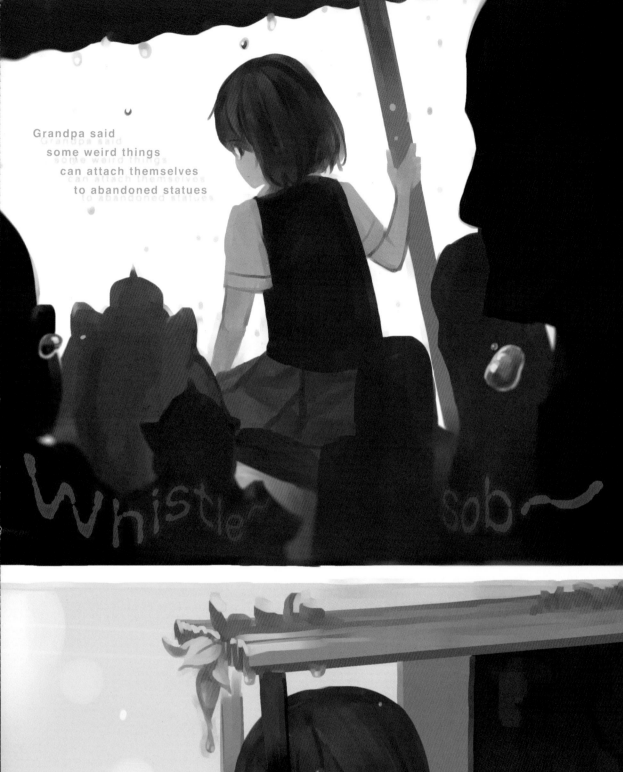

Grandpa said
some weird things
can attach themselves
to abandoned statues

Whistle~

sob~

Oh, the rain cleared up!

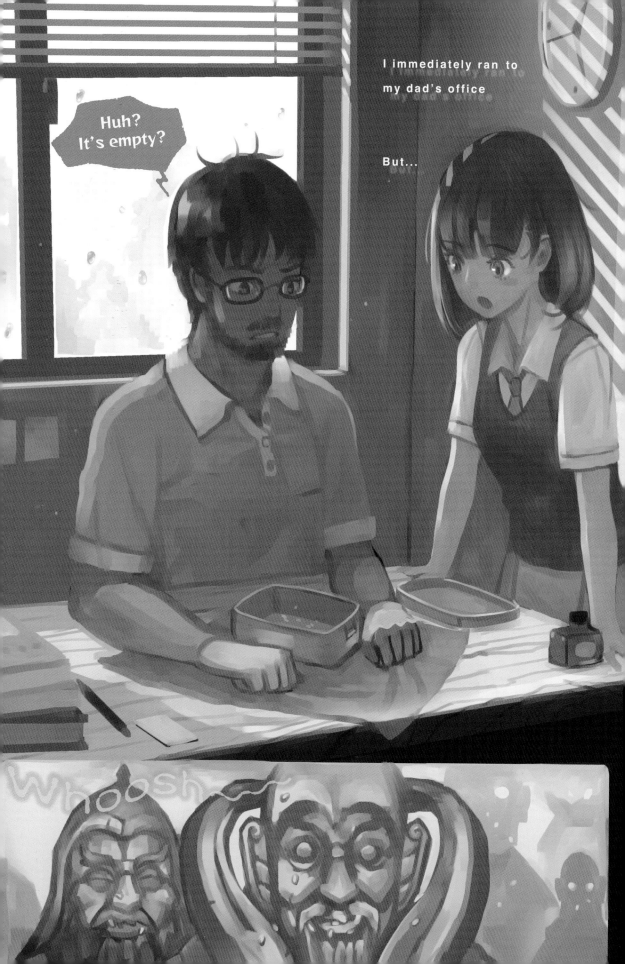

"A RAINY DAY"

One day, on the way to an ecological conservation area in Bali District, I saw this tiny temple next to a rural road. Maybe the nearby villagers felt badly that all these washed-up statues were left in the sand, so they collected all of them under one roof for people to worship?

I thought it was interesting and was about to take a picture, but someone stopped me and said that since the statues were not from a proper temple and therefore had not been blessed, the spirits attached to them may not be godly. Besides, there were so many that you couldn't tell what was good and bad, so it was best not to take any pictures.

Indeed, seeing all those statues all crammed into the same shed to share the same fate on that rainy day did have something of a gloomy feel to it, but it was also very interesting, so I made it into a story.

Later, I passed by the area again, but the tiny temple had been moved into a bigger one, and the gloomy atmosphere was completely gone.

DREAM:08
THE ROLLING MARBLES

"Sometimes I'm afraid to go to sleep because I might have nightmares."

But when I'm lying awake, I can also hear things.
And when I hear that noise, I know it's time to sleep.

"Tok-tok-tok-tok-tok-tok-tok..."

See, there it goes again. I should just sleep...

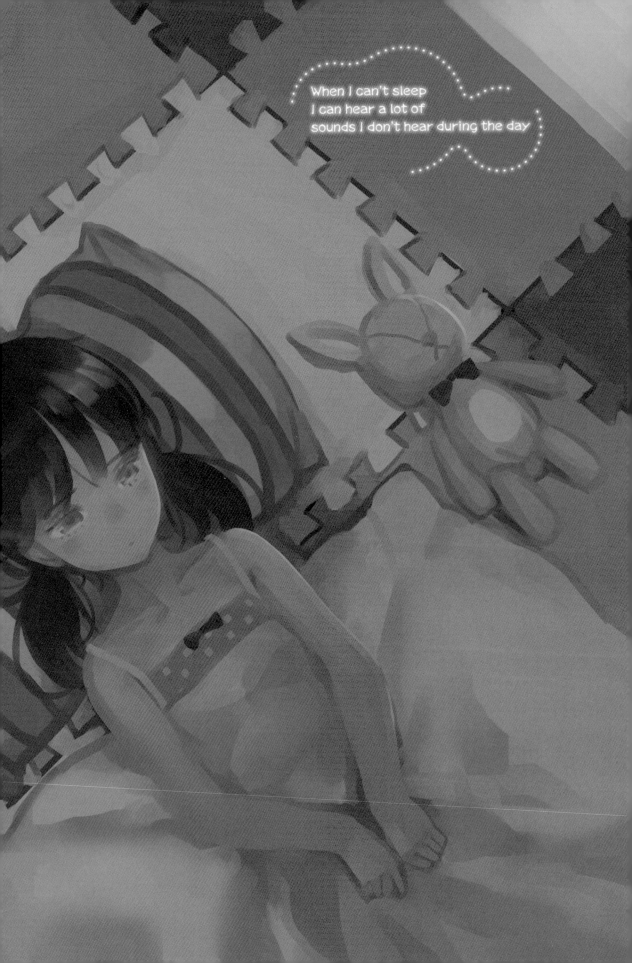

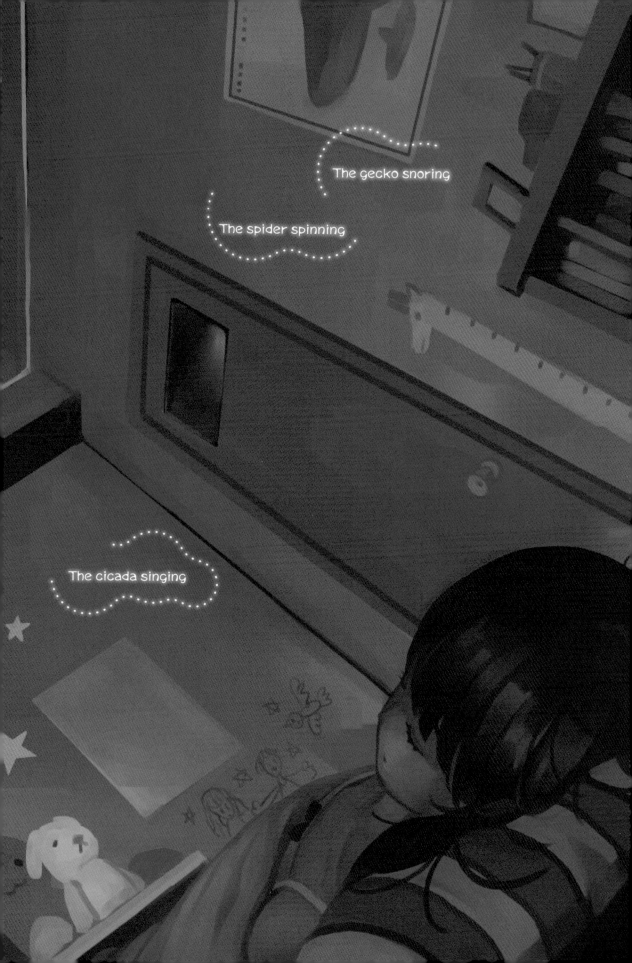

The weirdest one is
the sound of marbles rolling
coming from the ceiling

Whenever I hear this
I know

it's time to sleep

Because if I stayed awake
I'd definitely drown in all the marbles
rolling down

"THE ROLLING MARBLES"

I don't know if anyone remembers hearing the sound of marbles from the ceiling when they were kids?

I read an article that said perhaps 60-70% of Taiwanese people have experienced insomnia in their childhood, accompanied by a noise from the ceiling that sounded like rolling marbles.

I remember hearing a sound like that when I was little. I would tell the adults next to me, but they'd just impatiently tell me they didn't hear anything and go right back to sleep.

So, why can't I hear the marbles now that I'm an adult?

Was there someone who wanted to find a child to play marbles with in the middle of the night?

Or maybe children just have a stronger sixth sense?

But it takes all the fun out of it to try to analyze this logically. Let's forget it for now.

DREAM:09

ECHO ON THE BUS

"Did you know that when the bus passes the cemetery, strange voices will talk to you?"
"That's so scary! Really?"

Whenever I heard someone say this I'd snicker.

Today I also want to be the first one to get on the bus, and hide myself deep in the last row...

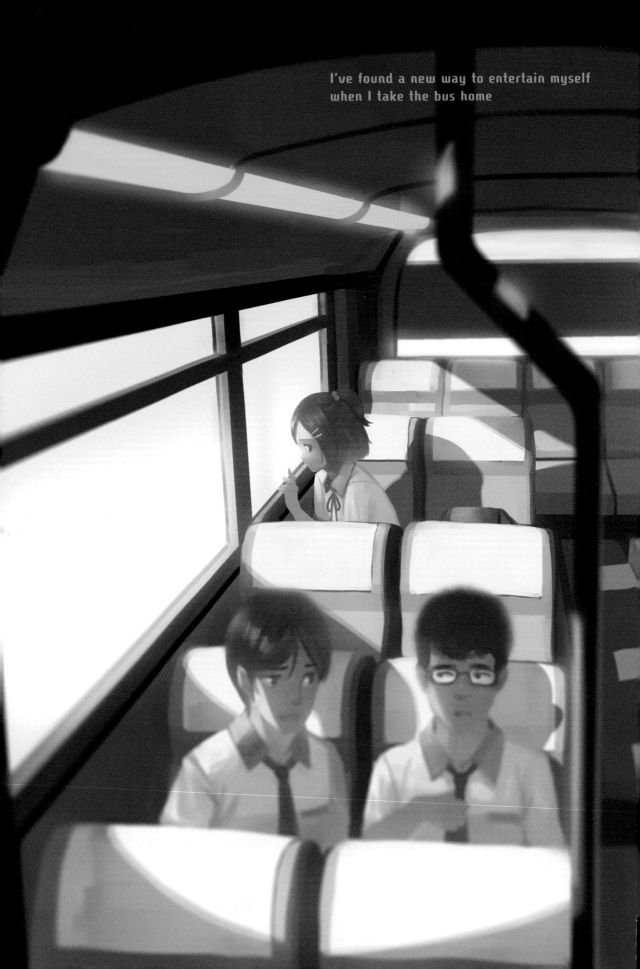

I've found a new way to entertain myself
when I take the bus home

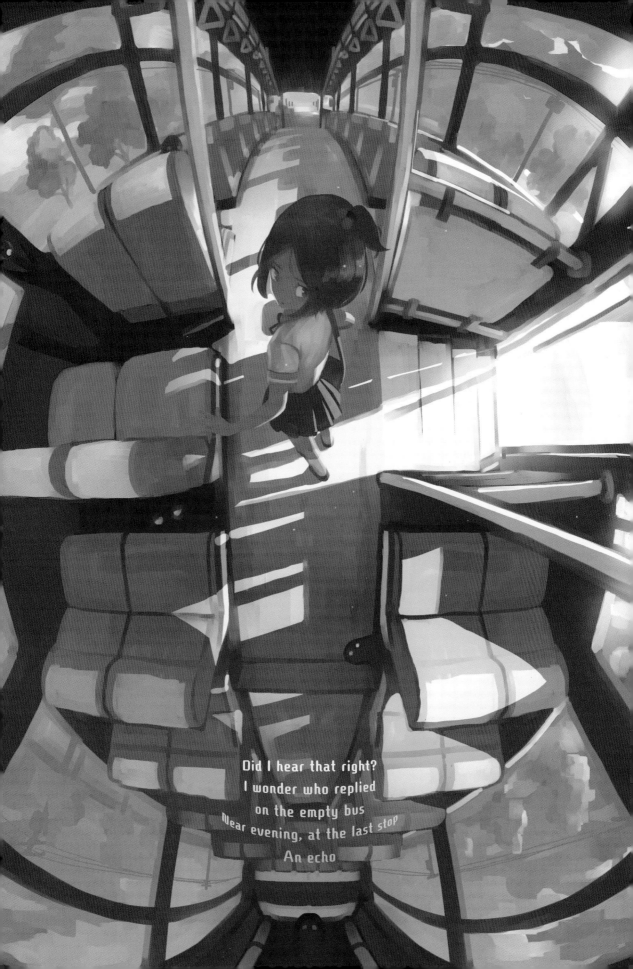

Did I hear that right?
I wonder who replied
on the empty bus
Near evening, at the last stop
An echo

"ECHO ON THE BUS"

A lot of funny things happen on a bus full of students. Whiteout on the backs of the seats. Bashful young couples blushing when their shoulders touch. If you end up on a bus of students, these youthful scenes will greet you.

Suddenly, the bus is pulling into the last stop and all the students have gotten off. Rays from the setting sun intermittently peek through the trees. The empty car has a shifting tableau of light and shadow, like a magic lantern.

At these times, sometimes I'm tempted to ask a question out loud and see who'd answer.

HIDE AND SEEK

"I've heard a cat's average lifespan is about 10 years."
"So the cat in my neighborhood must be a cat spirit already."
"Ridiculous!"

Really, I never figured out where it lives...

There's a black cat that lives nearby

Rumor is that it's over 20 years old
It still jumps and hops and runs

No one knows who owns it

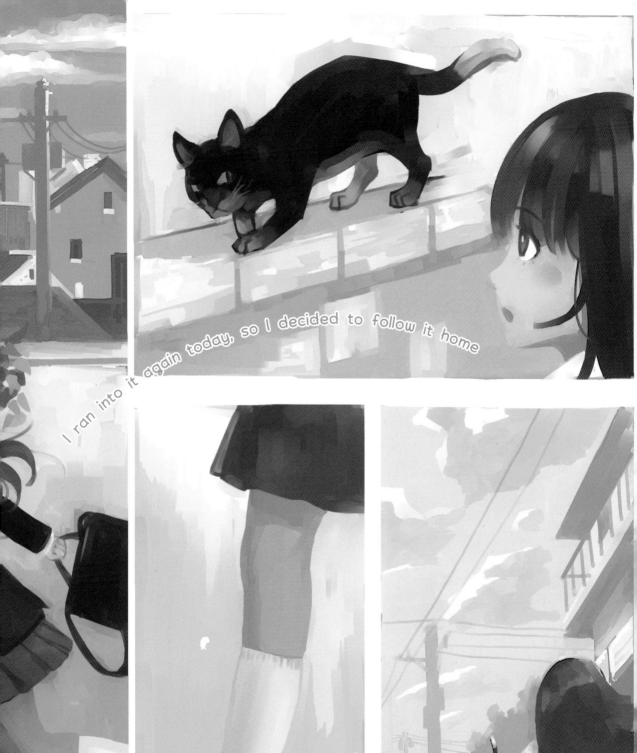

I ran into it again today, so I decided to follow it home

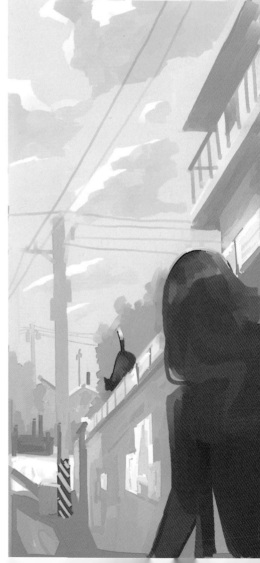

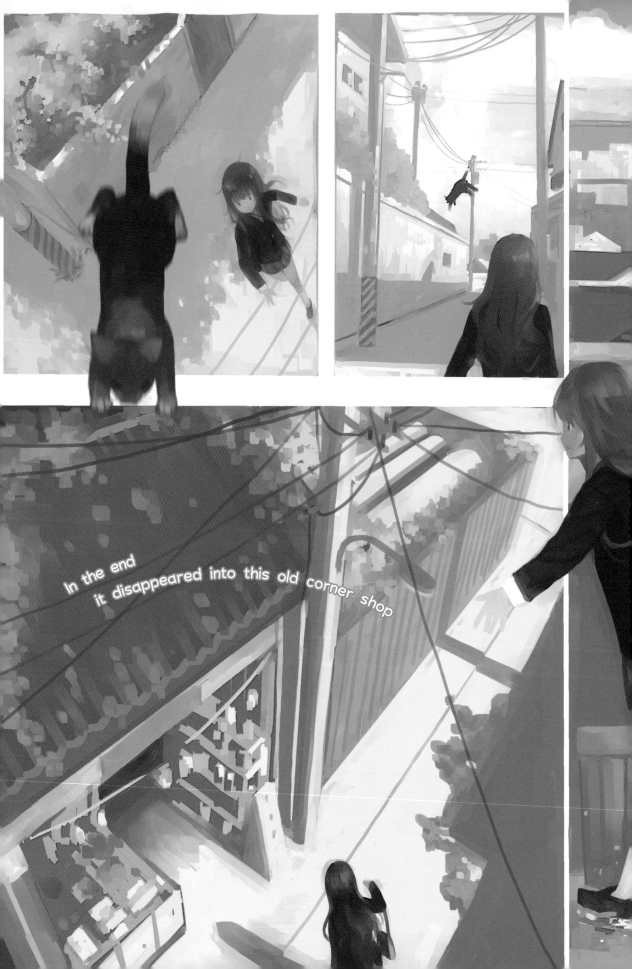

In the end
it disappeared into this old corner shop

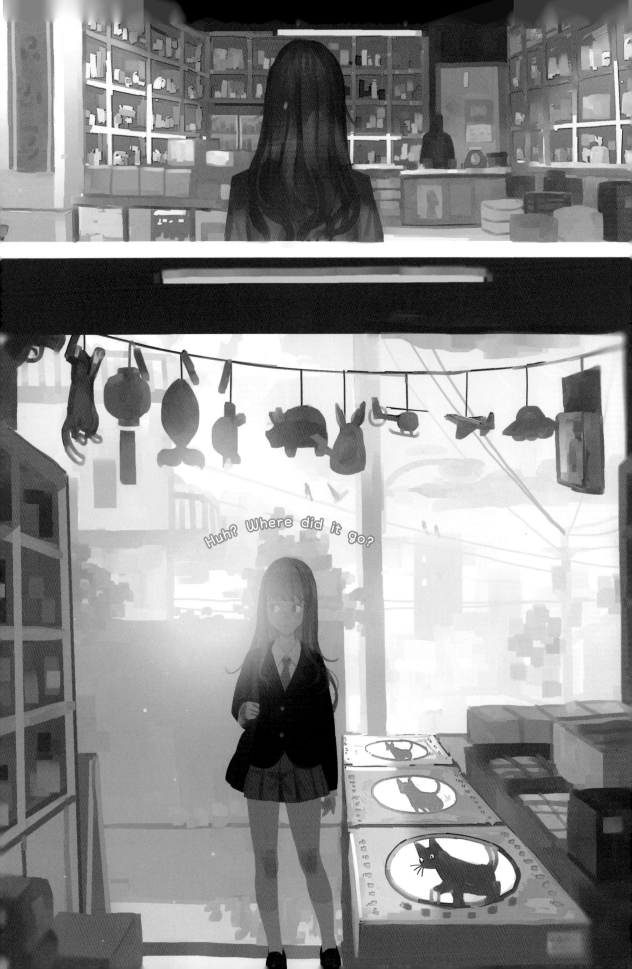

"HIDE AND SEEK"

A real corner shop is a living relic.

Surrounded by chain convenience stores, big supermarkets, and large shopping centers, these corner shops really can't compete. Since there are so few customers, most of them don't turn on the lights during the day, and only turn on the light in front of the door at night. It's so dark inside that when you pass by, you feel like it's steeped in mystery.

How many kids these days would want to buy toys at one of these corner shops? How old are those water guns hanging at the door? Those Superman toys' joints are probably totally rusted.

But look at the cat figurine at the side of the shop. You'll never see it in the daytime. It's only at night when she returns to the shop all dirty from playing that you know she long ago evolved into a cat spirit.

"I always thought it'd be so great to be a projectionist for one of those outdoor movies in a temple square"

DREAM:11

MEMORY OF A SQUARE

I miss the sound of the projector whirring and flip-flops hitting the ground,
the stench of gasoline, the taste of sausages,

the plastic chairs provided by the lady across the street, Bruce Lee's flying kick...

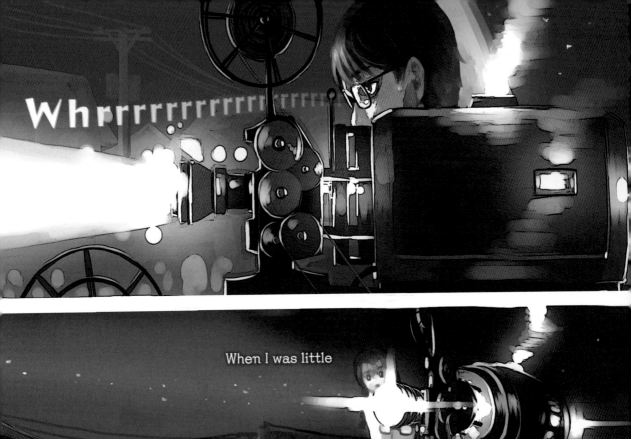

Whrrrrrrrrrrrrrrrrr

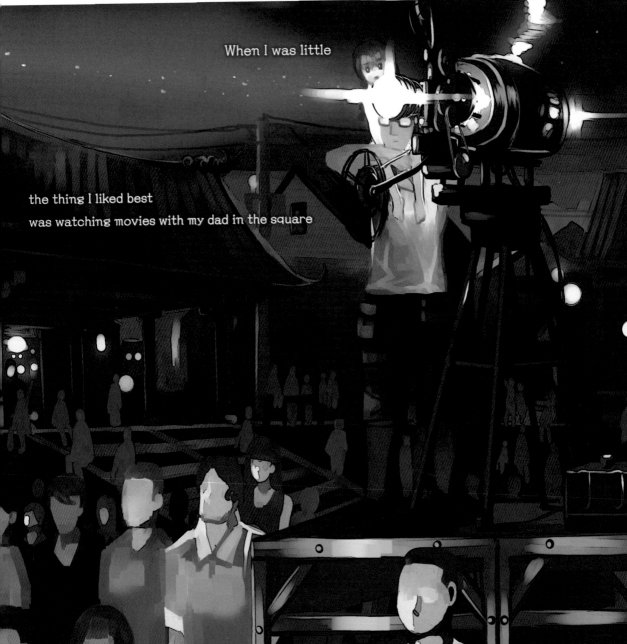

When I was little

the thing I liked best
was watching movies with my dad in the square

The temple square had a loyal audience:
children running around
hot sausage sellers
uncles unable to look away from the film
grandmothers dozing off
a yellow dog wagging its tail

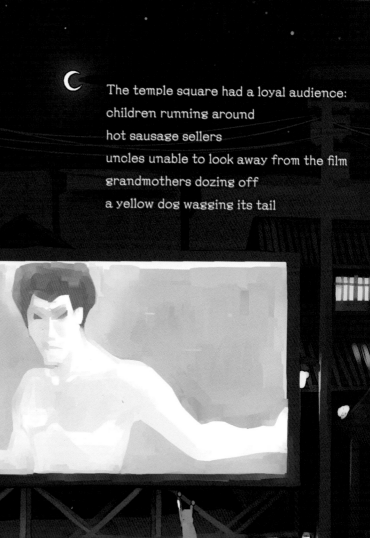

The projector blew out a white-blue smoke
filling the audience
with excited breath

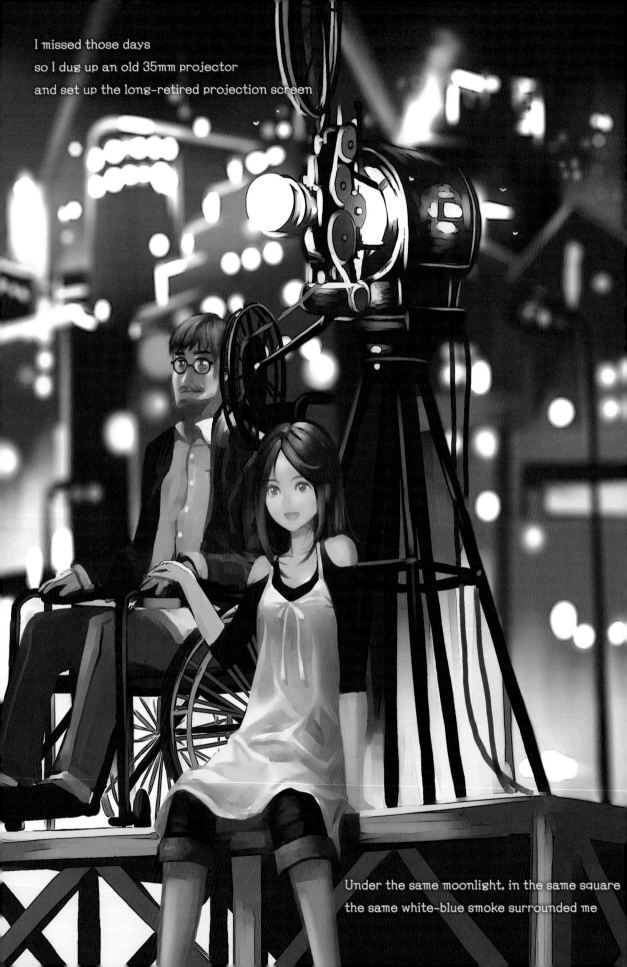

I missed those days
so I dug up an old 35mm projector
and set up the long-retired projection screen

Under the same moonlight, in the same square
the same white-blue smoke surrounded me

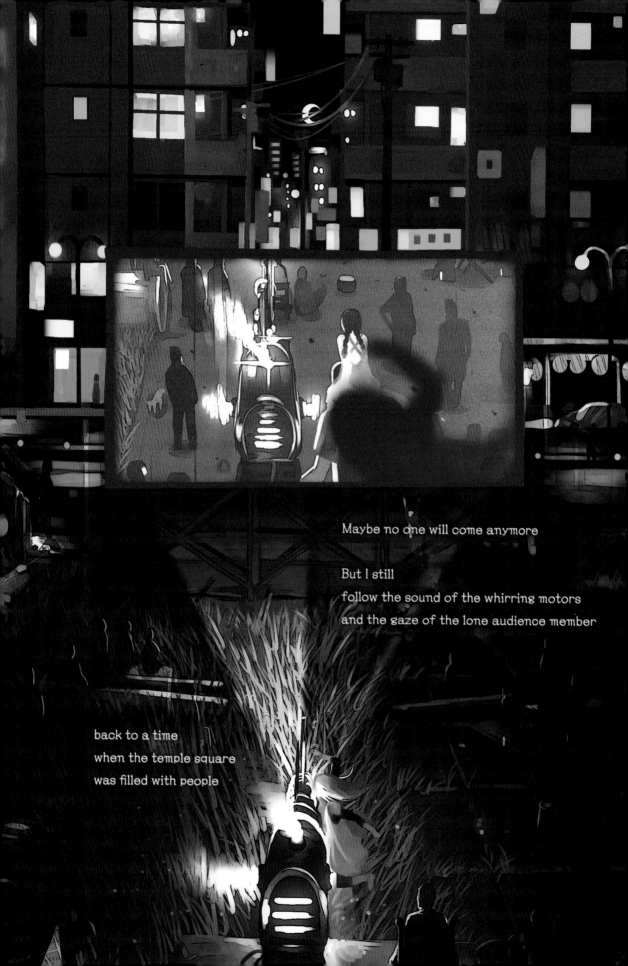

Maybe no one will come anymore

But I still
follow the sound of the whirring motors
and the gaze of the lone audience member

back to a time
when the temple square
was filled with people

ALL ABOUT

"MEMORY OF A SQUARE"

I've long forgotten the movies and the plots, but when I was a child, playing a film in the plaza during the temple fairs was like the opening signal for a carnival.

The projector was the center of everything, surrounded most closely by little rascals making shadow puppets into the light, then by adults focused on watching the movie. On the outer circle were stands selling sausages and soda pop. And on the outermost ring from the projector was a merry-go-round.

The projectionist had a near-holy presence. Like a circus trainer, he controlled the mood of everyone in the square.

These days, it's rare to see any outdoor movie events.

The square near my old home has long since become a parking lot.

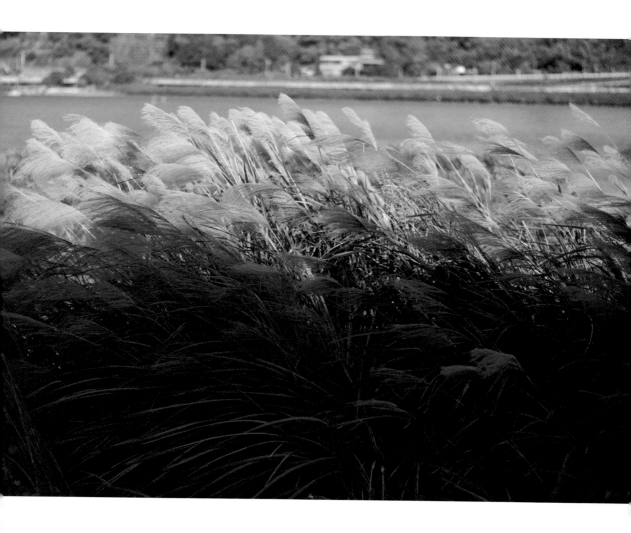

PERSONAL STYLE

"No matter how you dress yourself, your personal air won't change."
"And I can totally imagine what that air is in my head."

Today, I'm still searching for that distinctive identity, closest to my heart...

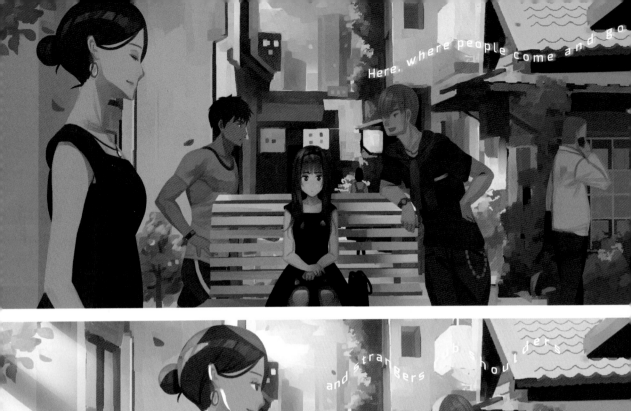

Here, where people come and go

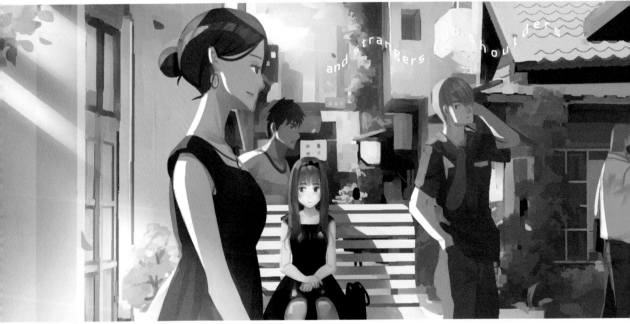

and strangers rub shoulders

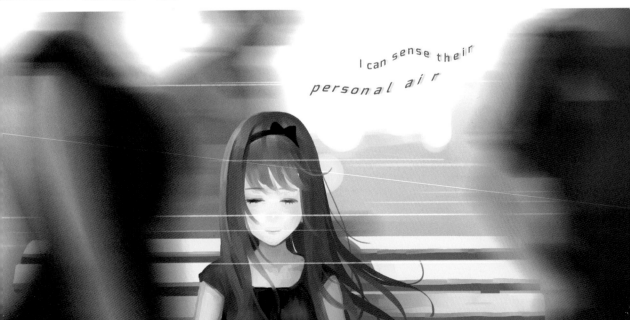

I can sense their

personal air

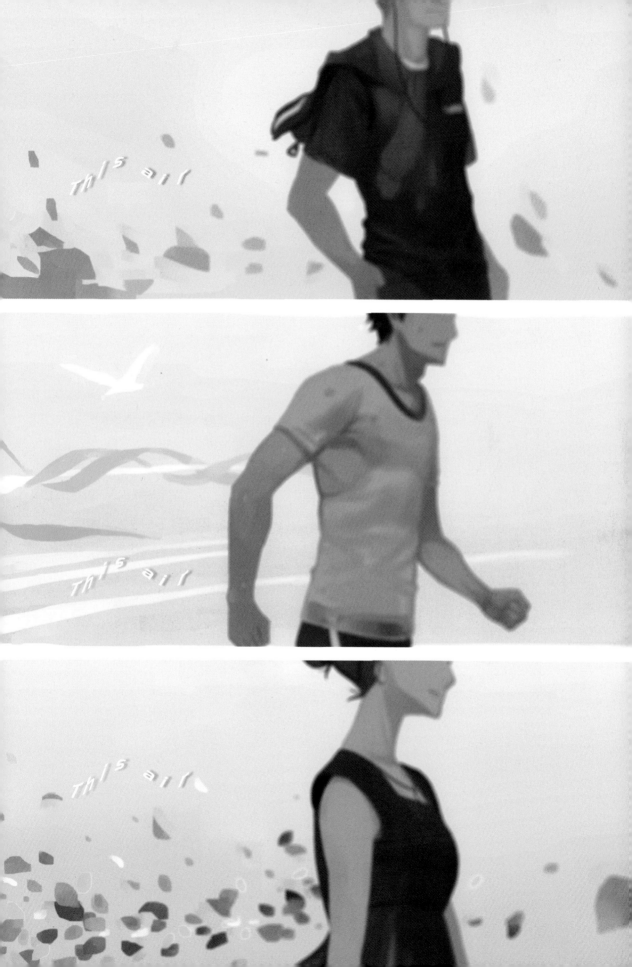

reminds me of a deserted town

reminds me of a tropical ocean

reminds me of a beautiful rose garden

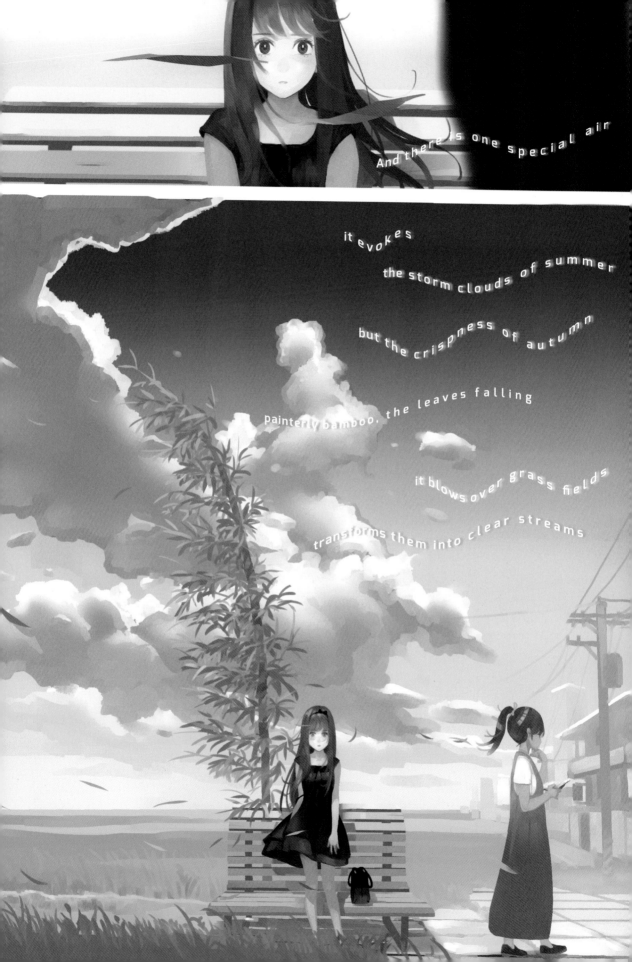

And there is one special air

it evokes
the storm clouds of summer
but the crispness of autumn
the leaves falling
painterly bamboo,
it blows over grass fields
transforms them into clear streams

ALL ABOUT

" PERSONAL STYLE "

On the bus, in the streets, in places where people come and go, when you rub shoulders with strangers, their individual air will flow towards you. This air is their own unique stamp and quality.

It may be the pungent scent of perfume (she must have a service job) or cologne (a successful, balding middle-aged man). Often there is also the stench of sweat (without even looking I'll know it's a healthy young man on the way home from a game). The most common smell is body odor (please hurry home and take a shower). Or it could be the smell of milk, or the sweet scent of books. These aren't mere smells, you can also whiff out people's characters.

When I'm sitting on the side of the road, I often observe the passersby's scents. While I'm absorbed like this, one compelling scent may flow by that makes all my pores open greedily.

In that instant, I can't say what the smell is. It makes me think of a tall mountain valley, or of maple leaves slipping one by one into a clear stream reflecting the brilliant sky, making a noiseless sound. I can't describe it. It just smells like that.

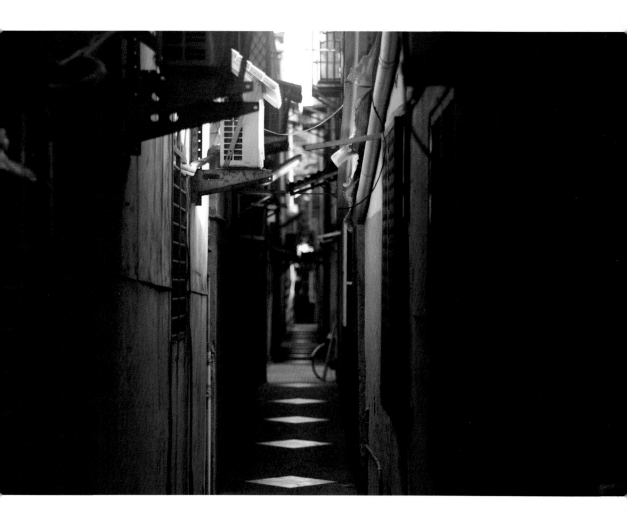

DREAM:13

SNOW IN SUMMER

I got my clothes dirty with the graffiti on the wall,
water from the AC dripped onto my face,
and I accidentally stepped on a dog's tail and jumped.

What? How do I like it?

Hold on,
let me focus first...

Spooling in the Fuji RVP100 film,
switching in the 5cm Hexanon lens,
I pick up my trusty Hexar RF camera
and get ready to explore another fire alley.

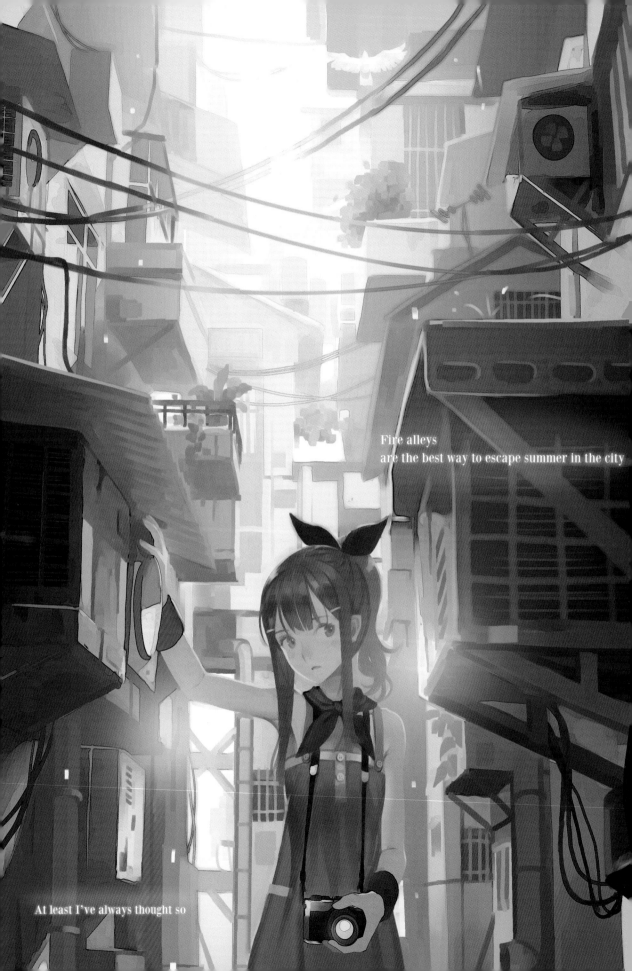

Fire alleys
are the best way to escape summer in the city

At least I've always thought so

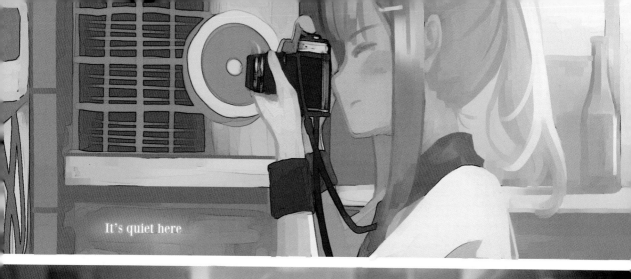

It's quiet here

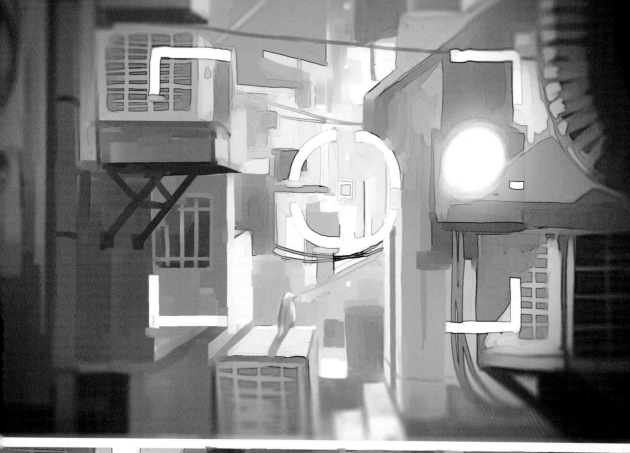

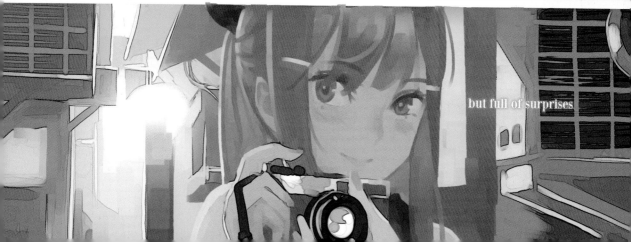

but full of surprises

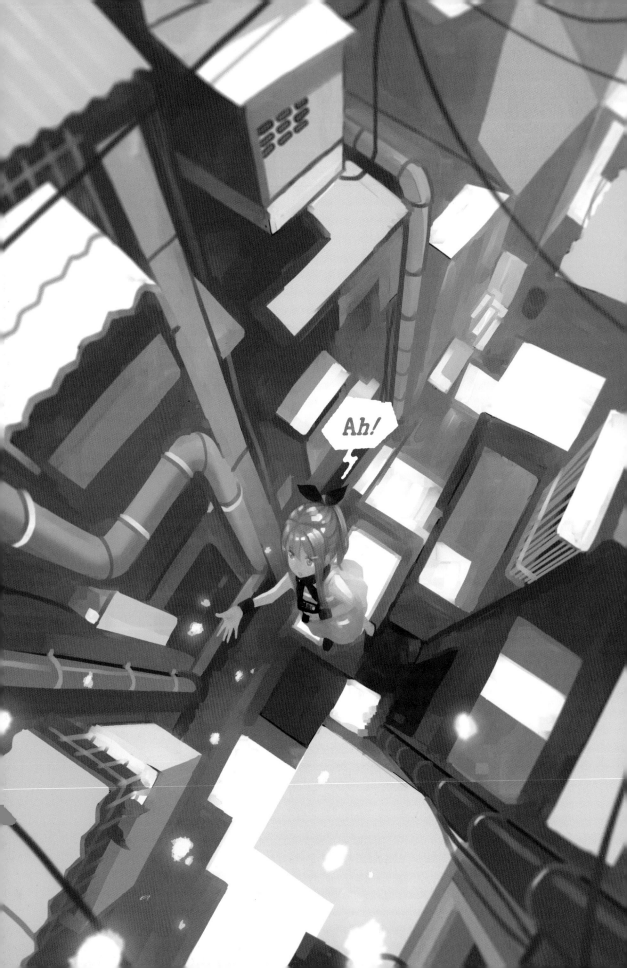

Cotton blossoms

are always the city's first summer snow

"SNOW IN SUMMER"

I really like fire alleys.

With every building, no matter how lavishly decorated the front and the interiors are, all the basic, fundamental, unadorned parts must face the fire alley—are built facing that dark wall.

One comparison would be to a person's rear end. Fire alleys are the maze created by the rear ends of all the buildings in the city facing each other.

Fire alleys are simple, clumsy places where nothing is created, and where you can see the purest form of life from behind. Abandoned bikes. Rusted washing machines. Pipes, kitchen ventilators, all piled up here.

Fire alleys are ruins we can see everyday, hyper-real places that get the closest to our lives.

So when you see someone sneaking around with a camera in your back alley, looking like he's trying to take pictures through your rear window, don't misunderstand. It's just me, really wanting to take a picture of that broken AC unit.

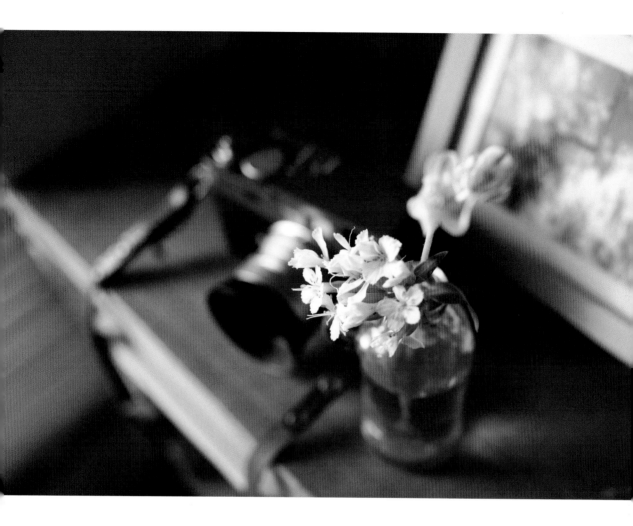

SPECIAL DREAM
PHOTOGRAPHER OF LOVE

I'm a photographer.

I shuttle back and forth on street corners, hiding in crowds, sneakily snapping portraits.

But I'm not just any old street shutterbug.

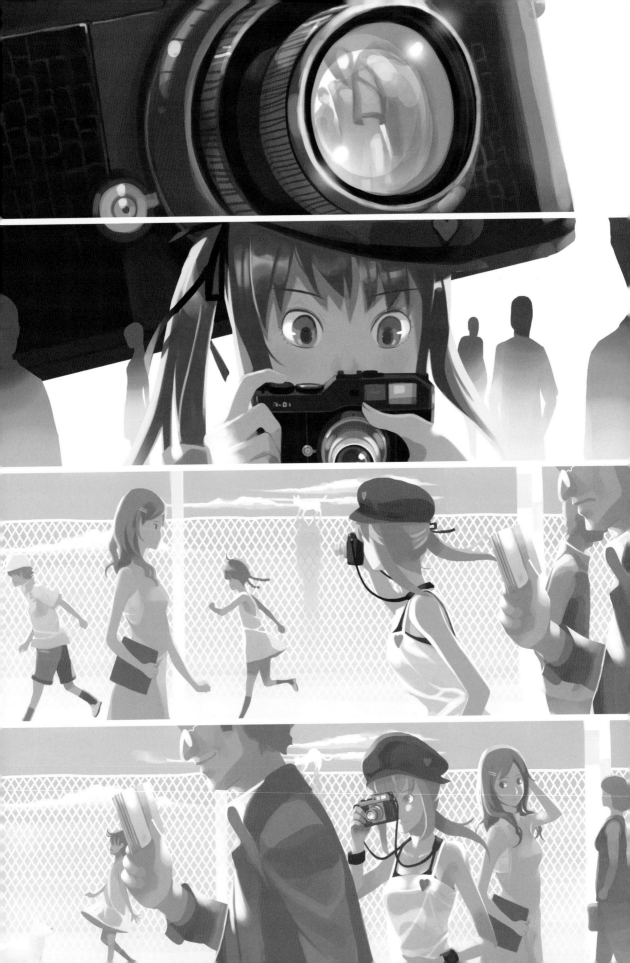

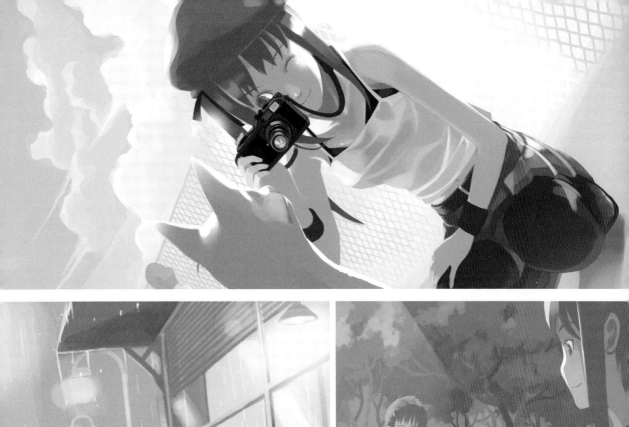
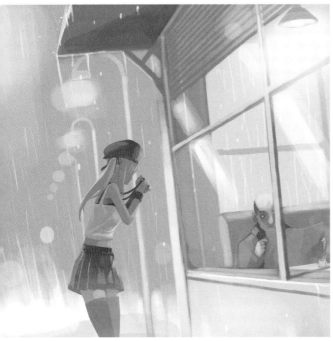
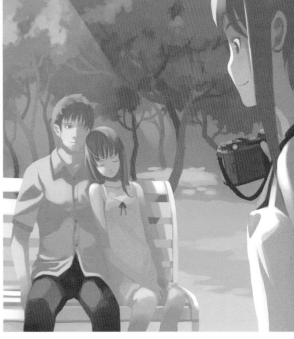
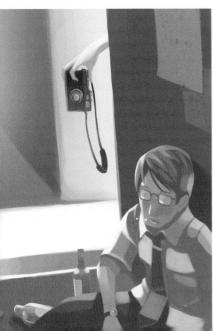
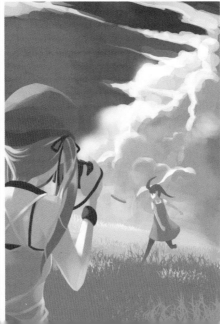
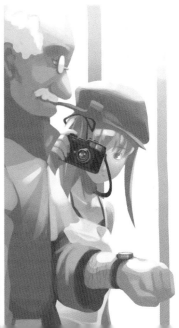

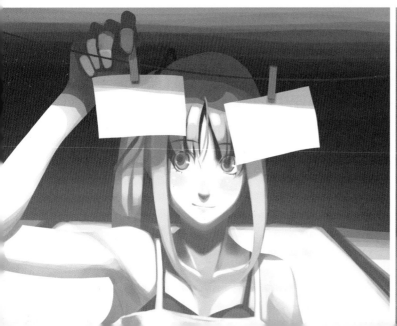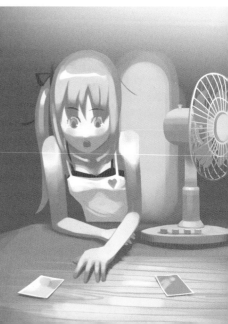

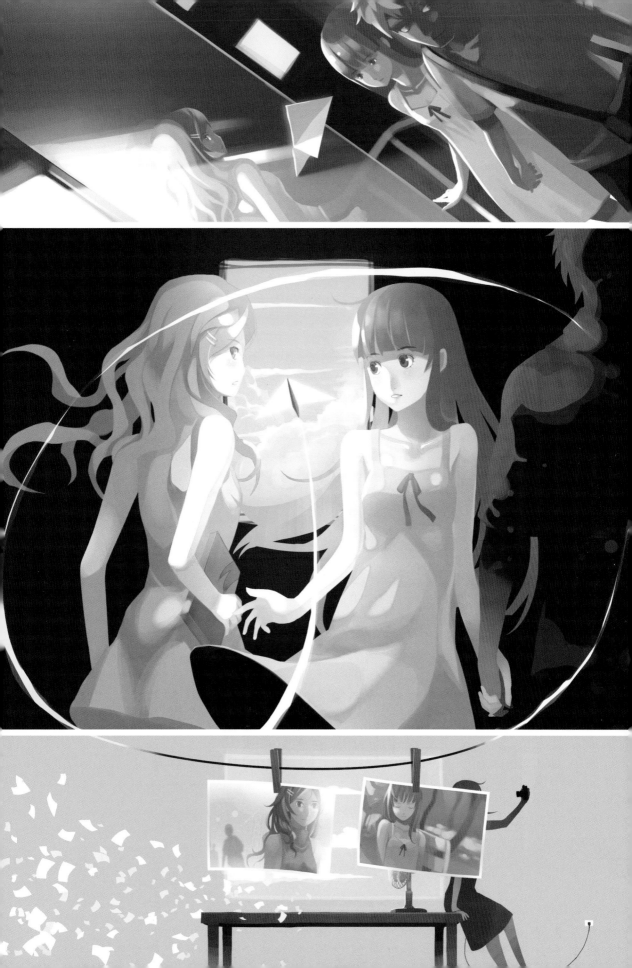

"PHOTOGRAPHER OF LOVE"

In college, when I first got started with photography, I bravely took shots of passersby on the streets.

High school students waiting for the bus, incoming commuters to work, elderly citizens sitting on park benches, youths on motorcycles. I'd raise my camera and didn't let a single one go.

After I developed the photos, I saw that over half the subjects were looking directly at my lens.

I don't know if they had sensed someone was taking pictures. Or perhaps someone taking photos outside of the tourist spots just makes himself really conspicuous.

There's an old superstition that says taking someone's photo will capture their soul. If that's true, then it's only natural that I'd be found out while secretly taking these passersby's souls.

But what should you do with the souls once you've taken them? Might as well use them to create some romantic encounters.

What do you think about when you're waiting for the bus?

These stories were serialized in the monthly magazine *Tiaozhan-zhe* [*Challenger Magazine*].

Every short story is independent of the others, and the characters are also unrelated.

These pieces dig into every aspect of daily life—aspects which were generally unearthed right before the deadline.

So they're rather unorganized short stories.

When we were planning these, the editor-in-chief said: "Draw some short stories that are really *you*."

In the beginning, I thought:

I O N S

"I should draw a story that has a totally different art style and plot for every issue!"

So ideally the first issue would have a Chitra Katha-style comic, another issue would have a macho American-style romance, the next issue would be about bullfighters drawn in a Chinese art style, and yet another issue would have a detective story styled after Hong Kong manga…

I don't dislike epics or stories of high drama. But the reality was that once I got started, the only images that came to me were:

A sparrow resting on the windowsill.

Chasing a rainbow over a wide grassy field after a rainfall.

Two planes' contrails crossing against a clear blue sky.

A cloud of colorful bubbles floating towards me in an alleyway at midnight.

Spending a morning exploring a ruin, with a ray of light peeking through a hole in the roof and landing on a touch-me-not.

A young couple that just started dating, eating microwave dinners from a convenience store on Christmas Eve, because they didn't make a restaurant reservation.

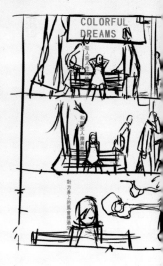

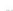

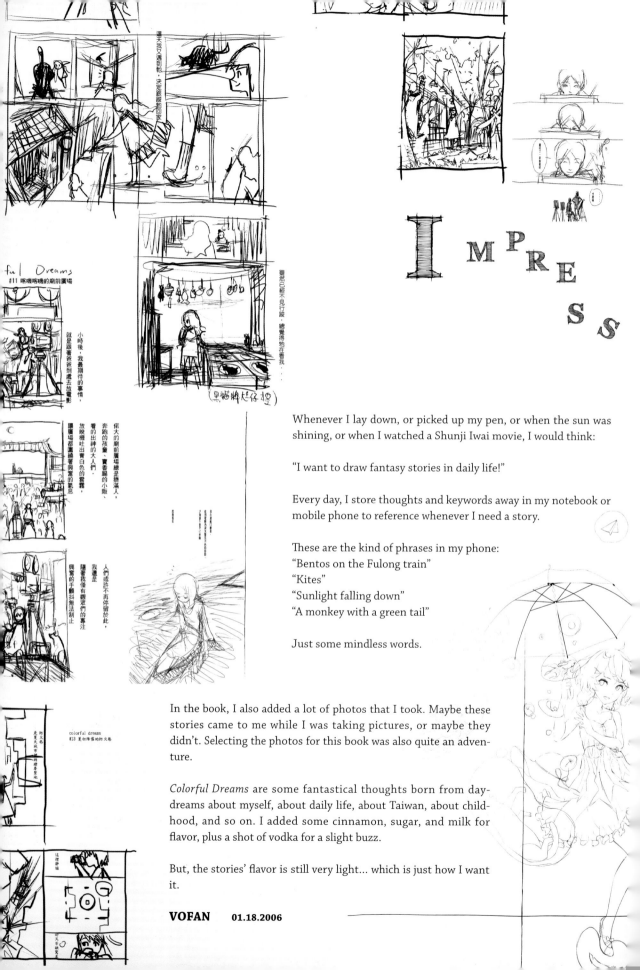

IMPRESS

Whenever I lay down, or picked up my pen, or when the sun was shining, or when I watched a Shunji Iwai movie, I would think:

"I want to draw fantasy stories in daily life!"

Every day, I store thoughts and keywords away in my notebook or mobile phone to reference whenever I need a story.

These are the kind of phrases in my phone:
"Bentos on the Fulong train"
"Kites"
"Sunlight falling down"
"A monkey with a green tail"

Just some mindless words.

In the book, I also added a lot of photos that I took. Maybe these stories came to me while I was taking pictures, or maybe they didn't. Selecting the photos for this book was also quite an adventure.

Colorful Dreams are some fantastical thoughts born from daydreams about myself, about daily life, about Taiwan, about childhood, and so on. I added some cinnamon, sugar, and milk for flavor, plus a shot of vodka for a slight buzz.

But, the stories' flavor is still very light... which is just how I want it.

VOFAN 01.18.2006

Lively Illustory

青　春　電　絵　物　語

Interview & editing: Elie Lin
Coordination: Junhong Zhuo
Interview from January 2006

VOFAN

A Taiwanese illustrator. He has been the cover illustrator for video game magazine *Famitsu Weekly Taiwan* since 2004 and served as the head of character design for the PS3 game *Time and Eternity*. Since 2006, he has been the cover illustrator for the *Monogatari* light novel series as well as for the mystery series *The Forgetful Detective*. He also illustrates PlayStation Network Taiwan's virtual avatar AI-Chan. As a photographer, he sometimes combines photographs with illustration in his work. His other publications include the *COLORUL DREAMS* series of illustrations and poems, and the album series VOFAN OTONA FANTASY.
https://www.facebook.com/vofanart
https://twitter.com/VOFAN_TW

— VOFAN, when did you start drawing?

That depends on what you mean by "drawing"! If doodling counts, then I probably started in kindergarten. I would draw as long as there was pen and paper, including adding beards to the portraits in my textbooks. I probably started drawing cartoons and original characters in second or third grade. At that time it was mostly Mega Man or BB Senshi, characters that are not human. In middle school I really got into Yuzo Takada's works, as well as *Yu Yu Hakusho*. Mainly I was drawing boys. I only started drawing girls once I started high school. Before middle school my style was pretty macho and I didn't draw female characters at all.

— That's surprising.

True. Since then it seems like I hardly ever draw male characters anymore. I only bring them out when absolutely necessary [laugh].

— That means your current style comes more from high school and beyond?

Yes. During my second or third year of high school—it's a bit hazy now—a friend showed me how to get on the internet. At the time the internet wasn't as common as it is now, and we were still using dial-up. We went to a department store where they had an internet promotional counter and used their computer to go online.

My friend showed me some image-hosting sites. Things were different back then. There were very few websites where you could post pictures. Up until then my social circle was very small. You could easily be the best artist in class, or even in the entire school, as long as you drew something—anything—even if your art was not actually that great. When I saw illustrations from awesome artists from all over Taiwan through the internet, I was shocked. That's when I started scanning the watercolor paintings I was doing at the time into the computer and got them onto these image-hosting sites. This was also how I initiated contact with the online world.

Also, because I would scan pictures into the computer, I started using graphic editing software like PhotoImpact to add some lame special effects. I think that's when I first started doing computer graphics, like adding some starburst or flashlight effects.

— Everyone wanted to use those when they first started using graphics software.

Exactly. At the time it felt very special just to have those effects; even adding a filter was super cool. But I only really started using the computer for illustrations after entering college. I bought a graphics tablet during my freshman year. From then on I mostly used the computer to draw.

— But from some of that art of yours that is still on the internet, your style really changed a lot after entering college. When you started college, why did you choose to major in architecture?

Well, I had no choice. My high school major was in the natural sciences. I think my parents wanted me to be a doctor or something, even though I personally had no such plans. But when I had to pick a major in college, there was nothing else related to art except architecture! So I had to choose architecture.

Most of the architecture courses during freshman year were still pretty interesting, like Drawing, Perspective Theory, Art History, and so on. But in sophomore year, we really got into actual architecture, and that was very challenging. This was partly also because from sophomore year onward I started taking illustration jobs and my focus was on that. To me, schoolwork was only something I did in my free time that helped train me in perspective.

— Isn't that kind of backwards?

Even to this day I still think architecture is very interesting. But after finishing college, I didn't feel like I could make it into a job. I couldn't make myself focus seriously on architecture.

But architecture did have a large influence on me in college...the biggest of which was training myself to survive all-nighters [laugh]. Sometimes the homework required me to draw continuously for 10+ hours with extreme focus, since any mistakes in the architectural plan would be disastrous during construction. I feel like that period of time trained my ability to focus and work all night.

I also learned some basic perspective theory. I didn't think much of it while I was learning it, but I realized later I could apply that knowledge to my own drawings. That's when I really understood the impact of those architecture courses.

— After graduating with your architecture degree, you got into the Digital Arts Department at the Center for Art and Technology at Taipei National University of the Arts. So basically your interests hadn't changed from high school.

When I was in college, even as an architecture student, I never stopped drawing a lot of CG (computer graphics) art. But I never received any formal training. After I got into the Center for Art and Technology, I realized that department also wouldn't give me the kind of formal training I was looking for, but I still think I got a lot out of it.

The Digital Arts Department didn't teach computer illustration or focus on the manual aspect of art. It was more about teaching a way to think. We learned how to use digital technology to realize formless creative ideas. We didn't limit ourselves to sticking to graphic design or internet media to get new effects.

— What did you get out of it?

Through this experience I realized the limits of my creativity. I was generally pretty satisfied with what I was already very good at doing, so this was an interesting test for myself. When I challenged myself with different techniques outside of what I would usually employ, I would always learn something from it, no matter how small. Then I'd apply that to the CG art, which was something that I was already very good at.

All the graduate students had their own strengths. Some people who were great at writing programs were not good at art, but they could use their programming skills to help others realize their ideas. Then there were design majors and artists who were very good at traditional methods of illustration or drawing by hand. The combination of these different skills could produce really unique results. This was a great learning experience for me. There were usually only a few people like me in any one class who were good at CG, but I think that was a good thing. If everyone in the class were good at the same thing, it would have been very boring.

Before middle school my style was pretty macho and I didn't draw female characters at all.

— Speaking of computer graphics, besides your experience in high school, why did you choose CG for creating your art?

Early on, I was just using image-editing software like PhotoImpact. That's not illustration, that's just adding some effects to pictures. But after a while, I grew bored with that so I started using Photoshop. First I was just using the mouse for coloring; I was still scanning the outlines of the pictures in. I only started doing actual computer graphics when I bought a graphics tablet.

A large reason why I settled on CG was for convenience, the same reason a lot of people go into CG. If, for instance, you wanted to use traditional pastels or watercolor, you have to go buy the materials first, and get your hands all smudged. But with the computer, you just need the computer. And if you make any mistakes you can just undo your previous step.

But the most important thing to me was that using CG allowed me to experiment more. I could immediately try to make whatever came into my head happen. With traditional art, for example, it's almost impossible to combine hand-drawn characters with real background images. If you fail the whole project is ruined, so you're less likely to attempt it. To do the same thing on the computer is much simpler and you can immediately try again if you mess up. You can experiment freely.

— How do you study digital drawing techniques?

Mainly through self-study. When I started using CG, most people were still mostly drawing by hand. They only used CG to add effects or adjust colors after they'd finished the drawings and scanned them into the computer. Even though there were already many books that taught people how to use Photoshop, in Taiwan at the time there were still very few people who created art entirely by computer.

— At the time Photoshop 3.0 didn't have much support for illustrating, so did you mainly use it for coloring?

Yes. I had no one to ask for advice even if I wanted to. At the time those who knew CG were mostly in the gaming industry. They used the mouse to draw beautiful bitmap images, but that's not what I wanted to do.

There were textbooks, but they mostly just taught some simple Photoshop commands. In the end I had to figure things out on my own. At that point, because no one could tell you the most effective way to create art, you figured out a workflow that worked for you after playing around with it for a long time. And that's the best approach for learning anyway.

— Are there any experiences you want to share?

Because computer effects are so easy to do, it's tempting to just fall back on special filter effects and abuse those tools. For instance, for convenience's sake you might randomly paste a photo into the background. That's part of the fun with CG. Since this isn't something you can easily do with traditional art, I think this type of creative process should be encouraged. But relying on special effects just to make images flashy and not hand-drawn will still inhibit your artistic growth.

From my experience, you can play with computer effects, but that cannot be your main selling point. If "computer effects" is your main specialty, then your CG will lack character or creativity.

— Your art is particularly distinctive for the "atmosphere" that permeates the image, an ambience created using color as light ["light=color"]. Is there anything you pay special attention to or insist on for your choice of colors?

I don't know whether I am very particular or whether I just don't know how to do it any other way? People have said I like to use a lot of blue, or that my colors are a bit light, so sometimes I do want to do something different to change what others think about me. And I would try to use darker colors. But then I'd realize I can't escape my style of drawing or coloring because that's just the way I want to draw! It's not that I can't use less blue, or that I don't know how to use darker colors. It's that once I start drawing, I just naturally use a lot of blue.

— Does that have something to do with your personality?

Yea, maybe my personality is blue [laugh]. But in terms of "atmosphere," I am very conscious of foreshortening.

— **Foreshortening?**

I am very aware of the color differences between things that are far away and near, as well as the haziness in between. I also emphasize perspective, because perspective determines whether or not what we're seeing is "natural." If we feel something is natural, it's because the placement of objects is in the right perspective, and mimics how they would be situated in the real world. If the perspective is a little off, people will feel there's something wrong with the image and think that it's "unnatural." I don't mean that I want the image to look like a technical drawing where the perspective is absolutely perfect. But it should feel right when we glance at it.

— **So the point is not "actual" perspective, but the "feeling" of perspective?**

Yes. I think that a picture with these two main elements, foreshortening and perspective, will have the basic factors that allow the viewer to become a part of it. This is just how I feel. A lot of illustrators or art book artists don't care as much as I do about those factors. We all have different requirements for our own work and like to emphasize different things.

— *Colorful Dreams* **has a lot of fisheye lens effect. Why?**

Escher (Dutch artist Maurits Cornelis Escher, 1898-1972, one of the most famous contemporary visual artists) used this technique a lot. I simply like this style of composition. Maybe it's because through a fisheye lens, you almost feel like you can pack the whole world into one image.

In some images, such as of crowded train stations or temple fairs, we can see that there are tons of people. But when we look at the picture, we get the sense we're looking at the scene from a distance, rather than as a part of it. But if I use fisheye, I feel like I'm very close to the scene. The perspective is super wide, so you can fit everything into the frame. It's like putting on the fisheye lens and standing in the middle of a square and using it to see everything around you. The opposite effect would be looking at the scene through a telescope from far away. The two perspectives feel very different and I like it when people feel like the artwork they're looking at is very close to their own world.

— **That kind of view is also something you don't see every day.**

Yes, it feels hyper-realistic. Using fisheye on a normal scene turns it hyper-realistic, because we don't usually see the world like that. Even though the fisheye effect is difficult to draw, I find the final product is deeply satisfying.

— **You also like photography. When did you start becoming interested in that?**

Around my sophomore year of college! I needed to gather some materials for my drawings so I started doing photography. Because of copyright issues, artists couldn't use images that we found online so we had to go take photos on our own when we needed to draw a background or get some independent reference material.

— **So you started photography for your illustrations?**

Yes. I bought a digital camera (they weren't nearly as common back then). In the beginning I really just wanted some reference material. If I needed to draw the sunset I'd take pictures of the sunset. If I needed to draw a car I'd take pictures of cars.

Eventually I became interested in photography for its own sake.

— **So through the camera, you found a new way to observe the world?**

You can say that. The interesting thing is that many of the images we see in daily life now are seen through a camera, like images on TV and in movies. We are very used to images that are formulated with a camera. So if a still life image, whether in CG or in a manga, seems different from an image you might get from a camera, then it doesn't feel natural.

so in order to draw in my own style, I need to experience more, learn more, and practice harder.

— The art styles for *Famitsu* and *Colorful Dreams* are very different. Why is that?

For *Famitsu*, I was drawing serialized covers, so there were a lot of requirements I had to meet. The characters had to be prominently placed; the primary focus needed to be on the middle of the image; there had to be enough empty space in the illustration for the magazine logo, etc. But *Colorful Dreams* allowed me almost complete freedom; I was drawing everything I wanted to draw. My only limitation was time, so I had to manage my time when it came to how long I spent drawing.

When I'm drawing for myself, I don't have any time limits, so I can make the image more complicated or put in a lot more things. But I couldn't do the same for *Colorful Dreams*.

— I heard you experimented a lot in *Colorful Dreams*?

When I was drawing *Colorful Dreams*, I didn't spend much time thinking about what I would create for the next installment. But whenever a deadline drew close, I'd suddenly get a lot of ideas. I would take some time to let these thoughts settle. These ideas were from all corners of life—not my own life, but rather all the interesting things and topics that I came in contact with then.

I first experimented with subject matter in the second story, "A Cafe." I wanted to introduce some supernatural elements into the story, but I didn't want to base them on any specific legend. That would be boring. I wanted to set this story in ordinary life, and maybe it would not be completely supernatural, but would have a supernatural atmosphere. I also wanted to draw Jiufen, a place in Taiwan. But I didn't want to draw the famous sites of that town; I wanted to capture the atmosphere. For example, in Jiufen it rains a lot, there are a lot of deserted streets, and some areas are next to the sea.

As for illustration technique, I didn't experiment too much with that in case I ended up with something really weird. Sometimes I really wanted to draw something random, something in the Hong Kong manga style or in the traditional Chinese-style art on New Year scrolls. Or maybe ukiyo-e style. But *Colorful Dreams* was supposed to be a series, so I couldn't go too crazy.

— Don't worry, if it's too out of left field the publishers probably would have rejected it [laugh].

That's true [laugh]. I also hoped that artistically *Colorful Dreams* could maintain a consistent style so I only experimented with subject matter in the stories. I didn't have any requirements for the topics I would be drawing, but I still wanted to play around, mainly exploring fantastical experiences in daily life.

The themes in *Colorful Dreams* are from ordinary life, but each story only has four pages so there couldn't be too many twists and turns. But when I think up a story, I still want it to have the basic stages of a plot, so that was a big headache. For example, say I need to create a story around the word "kite." This was very difficult for me; I especially found my resolutions to be weak.

For me, illustrating is very enjoyable and relaxing, but coming up with a story is totally different. I can usually finish the artwork in two or three days, but I may have to spend a whole week to come up with a very short story. The worst part is that I could spend a long time coming up with a story, but then I'd worry it wasn't very interesting. This was probably the most

annoying part. But because *Colorful Dreams* was serialized, I couldn't miss the deadline. So in those cases I'd only work on the art to make it as interesting as I could. That's quite a pain too.

If *Colorful Dreams* was just a comic strip, then I'd be in trouble if the stories were boring. But fortunately it emphasizes the feeling of the prose and the illustrations, so the art could still make up for what's lacking in the stories.

—— You mentioned the pain of the creative process. Is there also joy?

Yes! If I can put 80% of what is in my head onto the paper, I would feel great. But there are times when no matter how hard I draw, I can only come up with something that feels miles away from what's in my head, and I don't have enough time, and it becomes a pain again.

—— After the serialization of *Colorful Dreams*, you got work requests from Japan. Can you talk about this international working experience and how you feel about it?

When I found out that Kodansha Japan made a request through MAXPOWER Publishing, I was honestly flattered. I am not that famous in Taiwan. I'd never published a book. But somehow, someone in Japan saw my work and was interested in it... I really have to thank the introductions by the editor-in-chief of *Tiaozhanzhe [Challenger Magazine]*, Ms. Elie Lin, and the international liaison at Kodansha, Mr. Tamura, as well as the editor-in-chief of *Faust*, Mr. Ohta, for my opportunity on the world stage and successfully turning out work that everyone is satisfied with despite the language barrier. Of course, my editor Mao also helped a lot. Thank you to everyone.

—— And as usual for interviews with Taiwanese artists, please give some advice to our readers who want to go into illustration!

My personal suggestion is that everyone should keep practicing hard. But if you only work hard in one direction, there will be limits to what you can do. You may end up with just a single mode you always work in. I recommend that people who want to work in illustration try out different fields, take that experience and apply it to your art. That's how you build your own style.

When I was in middle school, I drew whenever I was bored. Usually I copied the style of artists I liked. But after I got really good and could imitate their styles perfectly, I still felt something was missing. The art didn't have a life of its own. Then I learned photography and came into contact with a lot of different people and situations. I also kept practicing my art, and that's how my style started to form.

Generally, imitation doesn't spur creativity. I think you can bring anything into making art, so in order to draw in my own style, I need to experience more, learn more, and practice harder. I don't think there's a shortcut for this. I'm still exploring. Let's work harder together.

UPDATED MESSAGE FROM VOFAN, 2019

—— Congratulations on having *Colorful Dreams* published overseas! How do you feel that this is now being published outside of Taiwan?

Colorful Dreams was a product of my youth. Now that it's being released in a different language, I'm really brought back to my younger days. My art style from 10 years ago is very different from my style now, and it's being released in countries with a different culture. I don't know whether overseas readers will understand the essence of this book. I'm excited and nervous.

—— Your art style has changed over the years. Even comparing the artwork from 5, 10 years ago we can see your techniques have evolved. As an artist how do you keep doing so and will we see another evolution 10 years from now?

An illustrator needs to tell an entire story with one image, so I can't fall behind in honing my artistic techniques. Even though artists' individual styles are important, I also need to be mindful of market trends and adjust accordingly. This is actually very hard to balance. In the past decade or so, illustrators around the world have been evolving. A lot of young people are showing off their amazing talent, and I have to continue to improve to keep up as well.

I usually approach life one step at a time so I have no idea where I'll be in 10 years. But maybe I'll work on simplifying my illustrations.

—— What are some of your aspirations for the future? Especially in the overseas market?

I've always wanted to experiment more with photography. Maybe I'll put more time into photography in the future.

The only markets I had been exposed to in the past were Taiwan and Japan. The US and European markets are very unfamiliar to me. But with the links from globalization, people from different countries are less regionally restricted when they look at creative works. So I think I'll just keep doing what I do best.

C O L O R F U L D R E A M S

Translation: Sze K. Chan

Design Direction: Akira Saito (Veia)

Design: Miyuki Yamaguchi (Veia) Yayoi Kaneda (Veia)

Production: Grace Lu

© VOFAN 2006

Original Traditional Chinese edition published in 2006 by MAXPOWER Publishing Co., Ltd.

Publishing rights for this English edition arranged through MAXPOWER Publishing Co., Ltd.

Translation provided by Vertical Comics, 2019

Published by Vertical Comics, an imprint of Kodansha USA Publishing, LLC, New York

ISBN: 978-1-947194-83-0

Manufactured in South Korea

First Edition

Kodansha USA Publishing, LLC.

451 Park Avenue South, 7th Floor

New York, NY 10016

www.vertical-comics.com

Special thanks to Elie Lin